THE ESSENTIAL PHOTOGRAPHY WORKBOOK

The Beginner's Guide to Creating

IMPRESSIVE DIGITAL PHOTOS

STEPHEN DANTZIG AND JOAN DANTZIG

AMHERST MEDIA, INC. ■ BUFFALO, NY

Dedication

For the one person who showed me what it meant to truly be in love: my beautiful wife Joan. Salamat my love. Mahal Kita.

Acknowledgments

There are too many people to thank for their support, guidance and direct contribution to this course. Many of them are mentioned by name throughout the book. My heartfelt mahalos (thanks) to everyone mentioned and to those whom I neglected to specifically mention. You are all a part of this.

All images © Stephen or Joan Dantzig except where noted. Noted photographers own all copyrights to their images and have given permission for the use of the photographs in this book. Photo by Max Brunk.

Published by:
Amherst Media, Inc.
P.O. Box 586
Buffalo, N.Y. 14226
Fax: 716-874-4508
www.AmherstMedia.com

Publisher: Craig Alesse
Senior Editor/Production Manager: Michelle Perkins
Editors: Barbara A. Lynch-Johnt, Harvey Goldstein, Beth Alesse
Associate Publisher: Kate Neaverth
Editorial Assistance from: Carey A. Miller, Sally Jarzab, John S. Loder
Business Manager: Adam Richards
Warehouse and Fulfillment Manager: Roger Singo

ISBN-13: 978-1-60895-863-4
Library of Congress Control Number: 2014955647
10 9 8 7 6 5 4 3 2 1

www.facebook.com/AmherstMediaInc
www.youtube.com/c/AmherstMedia
www.twitter.com/AmherstMedia

CONTENTS

2. Exposure Essentials26

3. Controlling Exposure41

4. Creative Applications46

5. Quantity of Light59

ABOUT THE AUTHORS

Stephen Dantzig is a nationally renowned lighting expert and owner of the Hawaii School of Photography with over thirty years of experience behind the camera. He is the author of *The Essential Photography Workbook: The Beginner's Guide to Creating Impressive Digital Photos, Portrait Lighting for Digital Photographers: The Basics and Beyond, Lighting Techniques for Fashion and Glamour Photography for Film and Digital*

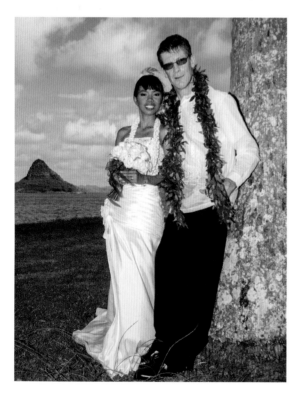

Photographers, Master Lighting Techniques for Outdoor and *Location Digital Portrait Photography, Softbox Lighting Techniques for Professional Photographers* (all from Amherst Media) and *Photographing Swimwear: Lighting, Composition and Postproduction, On the Set and Behind the Scenes, The Making of a Maritime Fashion Shoot,* and *Professional Make-Over Techniques* (ProPhotoPublishing). Stephen has written more than one hundred articles and lessons on photographic lighting and ethics. He was a monthly contributor for eight years to ProPhotoResource.com, and his lessons have appeared in *Rangefinder, Professional Photographer, PC Photo, Studio Photography and Design, ProPhoto West,* ShootSmarter.com, and the Photoflex Web Photo School. He has also earned a Doctor of Psychology degree from Rutgers University Graduate School of Applied and Professional Psychology.

Joan Dantzig's first publication is *The Essential Photography Workbook: The Beginner's Guide to Creating Impressive Digital Photos.* She is originally from the Philippines, where she discovered her love for photography.

Thank you to our good friend Stan Cox II for creating a beautiful wedding portrait for us.

PREFACE

This book was over five years in the making. It began with an off-hand comment in a discussion I was having with fellow Amherst Media author Kirk Tuck. Kirk and I were writing for the now-defunct ProPhotoResource.com, and we were talking about the state of commercial photography. I mentioned that I'd had some success running small photo classes, and Kirk said something to the effect of "Why don't you start a school? You live in a beautiful place. It sounds like a natural fit." Hawaii School of Photography was born one year later.

Most of my professional writing on photography deals with advanced lighting techniques, and I offer these types of classes in my school. I also teach a couple of introductory-level classes. The latter are more popular than the advanced workshops, and I discovered that I thoroughly enjoy working with new photographers and showing them how to stop using their camera as an expensive point-and-shoot device. I love to see the excitement in my students' eyes when they begin to create the image that they want. It is magic.

Hawaii School of Photography turned four years old on June 1, 2014. This book is the culmination of those four years of helping photographers to move from the auto features of the camera to taking full control over the creation of their images. I wrote this book mostly from the first-person point of view, so you get the sense that I am talking to you, as a student in my class. I tried to anticipate and answer the questions that you might have if you were sitting with me in a park or in my studio. Almost more importantly, I packed in forty-five assignments for you to do on your own to increase your understanding of the concepts discussed and quickly improve your photography. Please take the time to complete all of the assignments at least one time, and be sure to complete them in order. The assignments are designed to build on each other. Go out and have fun with the process of discovering photography. It is an art form like no other, and one that I have been passionate about for more than forty-five years.

INTRODUCTION

Congratulations! You have entered the fascinating world of photography. You may have had a camera before, but you were using it merely to record whatever was in front of its lens. Until now, your camera decided how to record the scene. Now, by virtue of reading this book, you are beginning the process of *creating* the images that you envision.

Perhaps you just got a new camera that allows you to change lenses and take creative control over your images. Perhaps you have had your camera set to the "Auto" mode and are now ready to take control. Either way, you have made the huge leap from picture taker to image creator!

Digital cameras create images by reading the light bouncing back from your scene and translating those light values into a binary or digital code. You will learn more about this process and how to manipulate your camera to create the image you envision rather than what the camera chooses. Image of the stairway to Mag-Aso Falls, Philippines, by Joan.

What happens optically has to do with the way light travels. Light moves in straight lines unless it is bent by opaque substances (more on that later). The image created on the film/sensor is a rendition of the light bouncing off whatever you photograph. Once again, the light travels in a straight line, so the light reflected off of the top of your subject continues through the hole (your "lens") and records the image at the bottom of your film/sensor. (See http://users.rcn.com/stewoody/makecam.htm for instructions on building your own pinhole camera.)

With a twin-lens-reflex camera, the top lens was often used to focus the image, while the bottom lens created the image.

Cameras: A Basic History

This book is an introduction to digital photography. However, people have been capturing images since the 1800s. Film was king for decades before the advent of digital technology. Today, digital images are recorded on an image sensor. You are encouraged to study the history of photography to get a sense of where we have been and where we are going.

Cameras have changed over the years, and there are still many varieties in use. Pinhole cameras are perhaps the most basic type of camera available, and you can still make one today! A pinhole camera is a light-tight box with a pinhole poked in one side. Film is placed on the side opposite the pinhole. A flap of some sort covers the pinhole until you are ready to expose the film to light. To create an image (i.e., make an exposure), you simply open the flap to allow light to enter the camera. The basic pinhole camera is one of the best ways to demonstrate how light enters a camera and what happens next.

Twin-lens-reflex cameras were very popular. These cameras had, as the name implies, two lenses on top of each other. The top lens was often used to focus the image, while the bottom lens created the image. One potential problem with these lenses was a phenomenon called parallax: what you saw through the focus lens was not always what the creation lens saw—so what *you* saw was not exactly what you photographed.

Single-lens-reflex (SLR) or digital single-lens-reflex (DSLR) cameras solved this problem by using a series of mirrors that allowed us to see what the lens sees. "Old school" cameras had only manual settings—meaning the photographer set all of the controls. Further "advancements" put more and more of these controls in the camera and less in the hands of the image creator. These changes culminated in the point-and-shoot auto-everything cameras that are popular today. Sure, there are times when point-and-shoot cameras are great, but they won't do the trick if you want to have creative control over your images.

Cameras continue to evolve and we now have what are called hybrids (compact DSLRs, for lack of a better definition) and cameras without mirrors. The term "DSLR" is used throughout this book and is meant to include any camera that allows you

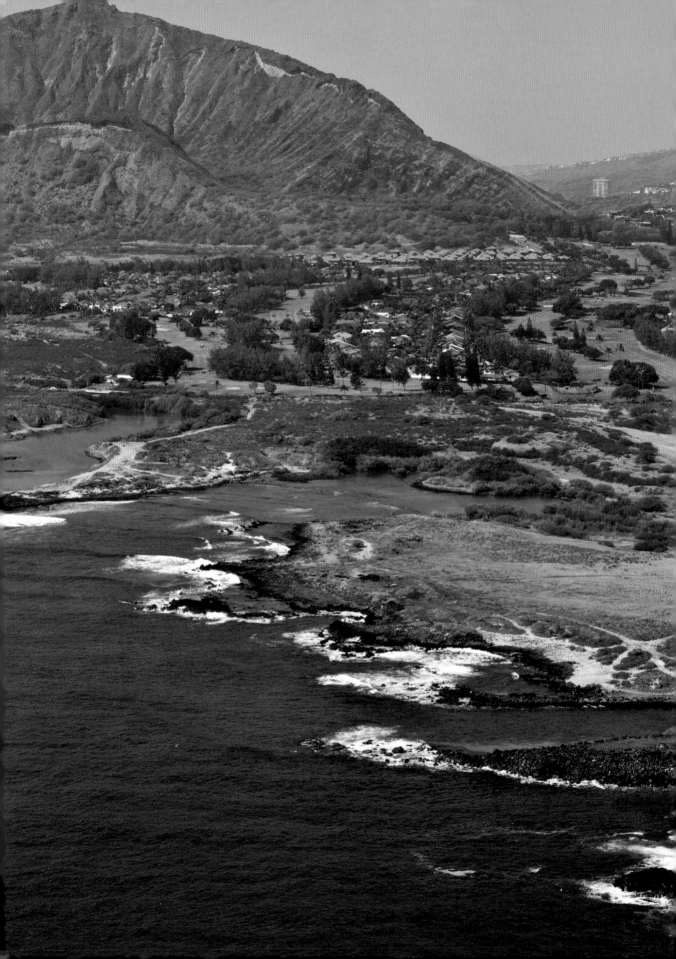

to manipulate the various creative controls available. Modern cameras can be expensive point-and-shoot cameras or a whole lot more! Your digital camera is essentially a minicomputer with so many options that it can easily become overwhelming. Let's take a look at some of the features found on most of today's cameras. Different manufacturers may call these options by different names and put them in different places on/in your camera, so look for them on your model and consult your camera's manual if need be.

Common DSLR Features

Menu. Your menu contains the folders and subfolders that house the vast majority of your camera controls. Some cameras allow you to access most of the controls via buttons on the camera body, but you'll be able to access the information from your menu options as well. The number of folders varies from one manufacturer and camera model to the next, but most have a tool folder, a setup menu, a playback menu, and a shooting menu. The main menu folders run along the top of the menu on some camera models. The folders run up and down the left side on other models. Each main folder opens a subset of options.

Info/Display Button. The Info or Display button is a very handy tool. It can be used to show a quick guide to your current camera settings and, in some cases, can be used to quickly navigate to specific controls that you might want to change. You

FACING PAGE—The design of SLR cameras makes framing and composing your image easy and accurate: what you see through the viewfinder is what you get in the image. This can be particularly useful when you are shooting in difficult and tight spaces like a little prop plane! Image: Coast line of East O'ahu leading to Kokohead Crater.

RIGHT—There is a lot to keep track of when you take over the controls from your camera. This is a good thing! However, it helps to get into the habit of checking all of your key menu options before you shoot. It is no fun "fixing" things in postproduction. Photo by John Yoshimura.

might need to find another button (like a "Q" or "i") to do this, but it can be easier than scrolling through the menus for the same control. The Info button can also be used on some cameras to change what information you see when you review (playback) your images.

Playback. The playback button looks like the triangle "play" symbol on any recorder or video player (including YouTube). It is used to preview or show the photographs that are stored on the memory card or stick. You can scroll through the photos and/or change the data displayed. You can show the image alone or with varying amounts of data (like exposure information and/ or a histogram). The way that you toggle through the data differs on different cameras. You are required to turn on some of these features in the Playback menu on some cameras.

Shooting modes determine how your camera will record the exposure. You have varying amounts of control over your exposure depending on the mode you choose. You change modes on some cameras by turning a knob on the top of the camera; other models may require you to access a menu. Don't worry if the attributes or terms used to describe these modes are foreign to you right now. We will cover them in detail throughout the book!

Auto Mode (A). Your camera is in full control when you are in auto mode; it makes all of the exposure and creative decisions. You essentially have an expensive point-and-shoot camera when you are in auto mode. In fact, many of your menu options are not available to you because you are not able to activate those controls. The camera chooses the ISO, aperture (f-stop), shutter speed, and white balance—basically everything.

PRO TIP

▶ LCD Caution

Don't use your LCD playback to make any critical or fine exposure decisions. Exposure control is your job in conjunction with a light meter. I think your LCD screen has too much contrast to be used to closely check your exposure. It can, however, be very useful for gross exposure checks, and if you have the "show highlight clipping" feature turned on, it will show you if and where your highlights (whites) are too bright to capture details. Your playback can also be used to check composition and to look for distracting image elements, like a tree branch that appears to pass through your subject's head.

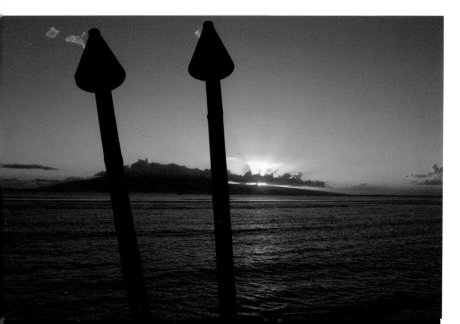

Program or auto modes usually provide an image with a good range of highlights to shadows. However, there are many times, like in this image of the sun setting over Lana'i off the West Coast of Mau'i, when you don't want the exposure range that the camera provides.

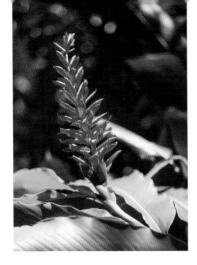

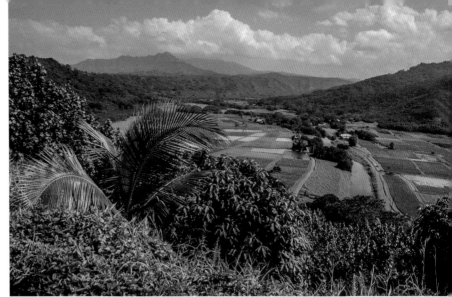

ABOVE AND TOP RIGHT—The background in the image above is blurred, which helps draw your attention to the ginger plant in the foreground. In contrast, the image of taro fields in Hanalei, Hawaii (right), is sharp from the coconut prawns in the foreground to the mountains in the background. We will discuss ways to control how much of your image is in sharp focus in a little while. You can alter your depth of field by using aperture-priority mode and selecting varying f-stops.

BOTTOM RIGHT—Waterfalls are often photographed in such a way that the moving water is shown as a creamy blur. You can decide how you want to show motion in your photographs and set the corresponding shutter speed with your camera set to shutter-priority mode. We will discuss this in detail later and show another waterfall with the water's motion frozen and blurred. Photo by Joan.

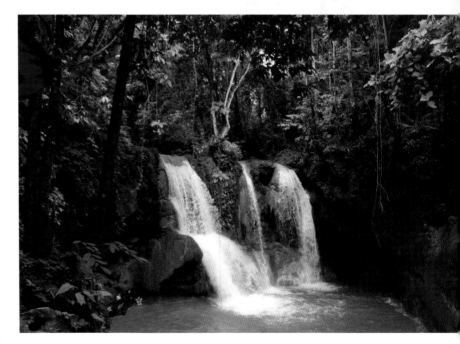

Program Mode (P). You begin to take some control when you switch to the program mode. You are now able to set the ISO and white balance, but the camera still chooses the f-stop and shutter speed.

Aperture-Priority Mode (A or Av). You set the aperture, ISO, and white balance, and your camera sets the shutter speed.

Shutter-Priority Mode (S or Tv). "TV" stands for "time value." You set the shutter speed, ISO, and white balance; the camera sets the aperture.

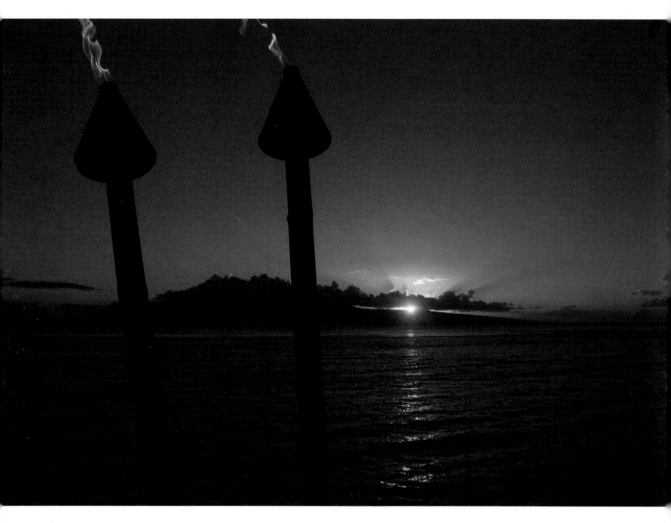

The image of the Maui sunset that we saw before is a perfect example of when you want to use the manual mode to override what your camera gives you to create the tonal range that you envision.

Some cameras have a Sensitivity Priority mode, but this is very similar to Program mode—you set the ISO and the camera chooses the f-stop and shutter speed.

Manual Mode (M). You are in full control over your camera controls!

There are a number of "creative" modes that you can set for motion, landscapes, portraits, etc., but these are essentially fancy versions of the aperture-priority or shutter-priority modes. You won't need them when you are through with this book!

▶ **There are a number of "creative" modes that you can set for motion, landscapes, portraits, etc., but these are essentially versions of the aperture-priority or shutter-priority modes.**

1. BUILDING THE FOUNDATION

The word "photography" literally means "to draw or write (graph) with light (photo)." The obvious start to this book is the question, "What is light?"

What Is Light?

Visible light is a narrow band of electromagnetic energy that produces different colors depending on the length of the light waves. Longer light waves produce green and blues, while shorter waves look red and orange. The distance between the crest and trough of the wave determines its intensity or brightness of the light.

Light appears white to the human eye. White light is actually the combination of all light. Black is the absence of light. The individual light colors are seen when a prism breaks up the light rays. We see that all the time in Hawaii where the misty rain over the mountains creates millions of mini-prisms that give us our beautiful rainbows. The visible light rays are red, orange, yellow, green, blue, indigo, and violet (ROYGBIV).

Photography is all about capturing wonderfully spontaneous moments as they occur. Developing an understanding of how your camera works will allow you to be free to capture these special moments. Stan Cox II created the photo of this great moment at our wedding.

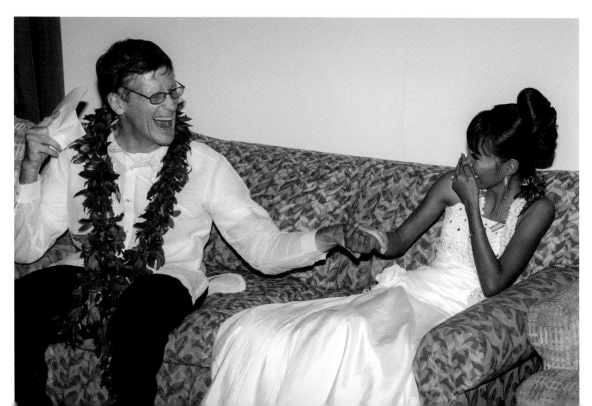

The seven colors of the rainbow are subsumed into the primary color channels of red, green, and blue (RGB) for photographic purposes. Secondary colors are cyan, magenta, and yellow and are opposite the primary colors on a color wheel. Offset printers use the CMYK color scheme (K stands for black in this case).

The colors and tonal values in your image are the result of light being absorbed and reflected at different amounts by the elements in your scene.

ASSIGNMENT 1

Let's back up now and take some time to discover what the camera has to offer when you use the auto mode. The point of this exercise is to get used to the feel of your camera and the kinds of images that your camera will create. (Please note that while this is an introductory book, it is not necessarily easy. It is very important for you to complete each of the assignments in sequence in order to get the most out of this book.)

Set your camera on auto mode and shoot several images in different places to get a feel for the camera and what it can do for you. Take notes along with the images and begin to think of how *you* would change the photographs. For example, the image might look like the scene you photographed in terms of colors and tones because your camera is an advanced computer that will usually give you a good exposure. However, is the photo what you envisioned? Is there too much or too little in focus? Is the image blurry where you wanted a sharp image? You will learn how to control these creative aspects of photography throughout this workbook.

Light does one or a combination of three things when it strikes something in the environment: it gets absorbed, passes through, or reflects off of whatever it hits. We will be examining these three effects throughout the book.

Capture Media

We commonly say we "took a photograph of . . ." or "captured a shot of . . . " That is not technically true. What happened when you set your camera on auto mode and pressed the shutter

The auto mode is a fine option if you are creating snapshots to simply record an event or thing. However, you will want to take advantage of the ideas and techniques described in this book whenever you want to use the camera as a tool to capture the image that exists in your mind's eye! The image of Ly Unt was created in full manual mode based on a meter reading from a hand-held incident light meter to ensure a precise exposure and the desired amount of blur in the background. The image was lit with a strobe in a beauty dish. Clouds acted as a scrim. You'll learn more about using flash and scrims later. Hair and makeup by Susan Ko-Morihara. Thanks to Orlando Benedicto for his help on the shoot.

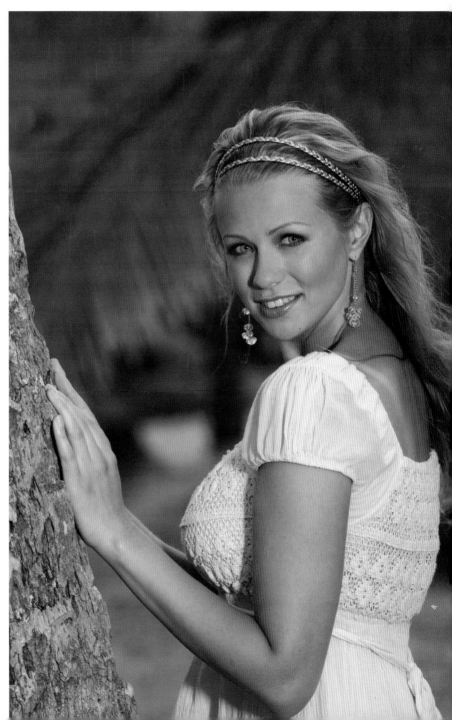

One of the huge advantages that digital photography has over film is the immediacy of the results. You can preview your creations instantly and make any needed adjustments in real time. Rayna Kitaguchi and Jayme Lee preview the image with me. Behind-the-scenes image (top) by John Yoshimura.

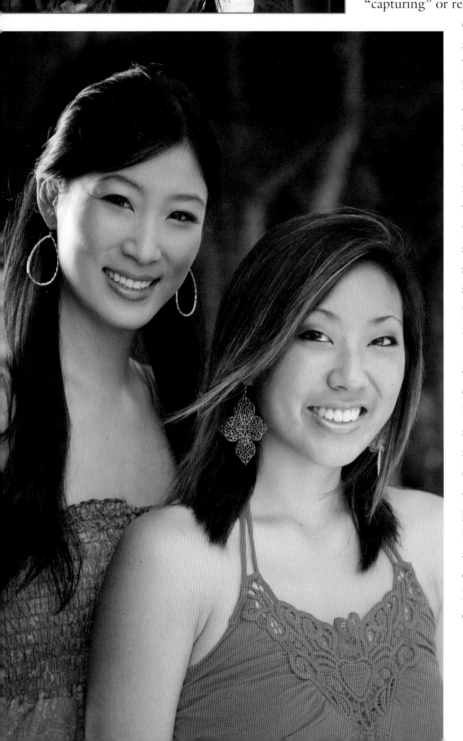

release? Your camera recorded a likeness of the scene in front of the lens. It did this by "capturing" or recording the light that reflected off of your subject. Think about that for a moment: What do we see when we look around? A tree? A car? A person with dark hair and a light shirt? The reality is that we don't see any of these things. We see the light that reflects off of what is in our world. Cameras do the same thing and "write" what the scene looks like onto light-sensitive material. The various shades and tones depicted in the photograph are made up from the light that is reflected.

The material used to create the images has changed dramatically over the years. Light-sensitive materials such as silver nitrates were spread over various papers, copper plates, or glass in the early days. The ability to fix a permanent image was mind-boggling in the late 1700s and 1800s, but the real game changer came when George Eastman introduced the idea of film.

Film. Film is a thick acetate substance consisting of an emulsion side with light-sensitive material and a harder protective side. The emulsion in film is made of silver salts (silver nitrates), which "grab" the light. Color films consist of different layers of emulsion designed to capture red, green, and blue hues. The silver nitrates react to the light and form a latent image in the emulsion. The film is processed in a series of chemicals to bring forth and "fix" the image. A "negative" film creates an image in which the tones and colors are the reverse of what we see. A negative is placed in an enlarger or other projective equipment, and the image is projected onto photographic paper or another form of light-sensitive material. The paper is processed and fixed to reveal a photograph. "Positive" or "transparency" film shows the image as we see it. Transparency film is also called "slide" film. The vast majority of information in this book pertains to film photography as well as digital, and we will refer to film from time to time as a point of reference for what is happening in the digital world.

The advent of film certainly did revolutionize photography in many ways, not the least of which was the introduction of the art form to the masses. Film was everywhere. You could develop and print your film yourself or take it to a multitude of labs where someone would process it for you. One drawback to film compared to the digital age was the time you had to wait between creating the latent image and seeing the final print (unless you were shooting one of the "instant" films like Polaroid).

Digital Sensor. Digital cameras do not use film. Rather, the image is captured via an electronic sensor that reads and interprets the tonal and color values within the scene that you are photographing. DSLR cameras come with either a full-frame sensor or a cropped-frame sensor. A full-frame sensor is about the area of a piece of 35mm film, and a cropped-frame sensor is smaller.

It might be difficult to imagine, but in some ways I think the digital revolution has had an even more profound effect on photography than the introduction of film. It took a while, but we are now able to produce high-quality images and view/share them with the world instantly. The technology has changed, but the essence of photography has remained the same. The sensor interprets the light and translates it into a digital code much like any other binary code. The information is recorded across red, green, and blue channels just like with film (without the delays and the chemicals).

Image Storage

Digital photography is truly phenomenal, but it has introduced a number of important aspects that we need to discuss before we talk about the mechanics of photography and how light works. Film, barring a major catastrophe, is a relatively permanent substance. I have not shot film probably since the year 2000, but I shot a *lot* of film before then. All of those images are stored away in boxes in my closets, so I could go back and find a particular image if I received a request from an old client. Digital photographs, on the other hand, are fragile entities that live a precarious life unless you take very good care of them. Digital photographs are actually specific types of files that "live" on our computer hard drives. In fact, most of our important information (bank statements, website passwords, early drafts of this book,

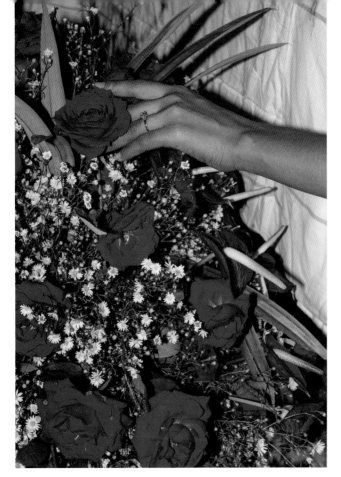

My wife Joan and I became engaged in Bohol, Philippines, in 2012. The images from that trip are priceless. Your digital images are the pictorial representation of your life. Digital files are fragile. Protect your memories with all diligence. "Murphy's Law"' applies to photographs too, so make sure that you have adequate backups of all of your images. The flowers and ring were photographed the night we became engaged. This and all of the other images are stored within a redundant RAID type of external hard-drive system. Be sure to make a backup of all important files, even if you are using a RAID system.

etc.) lives on hard drives. The question to ask in the digital world is not "Will my hard drive fail?"—it's "When will my hard drive fail?" You truly are tempting fate when you store your information on only one hard drive. It *is* going to fail. Therefore, the number-one rule in digital photography is to back up all of your important information, including photographs, in at least two places. The second rule in digital photography is "See rule number one!"

Hard Drives. The simple definition is that your hard drive is the place where you store your images along with many other important documents. Hard drives used to be big and clumsy parts of your computer, but nowadays they are much smaller and more portable. Your phone, for example, now contains a hard drive.

Memory cards or sticks are also hard drives. It is very important to recognize that hard drives are not permanent storage devices. They will fail at some point. Make sure that any important data is backed up in at least one other place.

Backup Systems. The need for more than one place to store your data is a reality and not a luxury in the digital era. You could use additional external hard drives, use a redundant RAID or DROBO-type system, burn your data to DVD or Bluray discs, or store them in the "cloud," but the bottom line is that you need at least one backup location. Hard drive space is so much cheaper than it used to be, and it just does not make any sense to keep all of your data in one place. Ideally, you want your backup to be off-premises in the event of a catastrophic event in your home or office.

Memory Cards/Sticks. Memory cards or sticks are placed in your camera and are used to store the images captured by your sensor. Memory cards are reusable once you offload the images or data. The devices are available in different sizes and "write speeds." Cards with slower speeds sometimes create a "buffer backup" that can impede you if you are shooting fast. DSLR video capture requires a faster card. Some of my students do not re-use their memory cards. They use them as a backup

to the information stored on the primary hard drive. This is certainly a viable, albeit expensive option. I can also see potential problems when you want to find that one image and you are staring at a stack of memory cards!

Image Transfer and Storage Options. We mentioned earlier that some photographers keep their memory cards full as backups to their data storage system. Most people re-use the cards. There are a couple of ways to off-load your images onto your computer to be able to use the card again. One way is to cut all of the images from your card and paste them into a file on your computer. I highly discourage this method because cutting the images from your card removes them from your card. This is a dangerous process because the images are gone if something goes wrong in the midst of transfer. I recommend a copy-and-paste method so the images are still intact if something goes awry. Delete the images from your card when and only when the images are safely backed up. At that point, you can prepare your card for reuse.

Removing Images from Your Memory Card. You have two choices when it comes to removing the images from your card: Erase/Delete and Format.

You can either delete the images (erase the card) or format the card. I have always heard that formatting the card does a better job of protecting your card from corruption, but there might be more to it than that. The format command wipes the File Allocation Table (FAT) clean, while erasing the images leaves the FAT intact. The actual data is still on the card and is theoretically recoverable with both operations—until you overwrite the data with new images. So, what are the advantages of one approach over the other? This is a more hotly debated topic than I realized, but there is still a lot of discussion on the web that states that erasing files only can eventually eat space on your card and can, as noted above, increase the likelihood of corrupting your card. I still format my cards each time I offload my images, but this might be overkill in light of my more recent research. I think a safe recommendation would be to format your card at least occasionally. I had an information technology specialist in one of my classes who recommended reformatting your cards every five downloads. That seems like a reasonable compromise.

File Types

Your camera will create something called a "digital file" with the pertinent information from your scene encoded. Digital files are what we create when we press the shutter release on a digital camera. You usually have two options when capturing an image: RAW or JPEG. You have many more options to save an image as different file types in postproduction. A detailed

discussion of the different file types is beyond the scope of this book, but here is a brief introduction to some of the more common formats:

JPEG (or JPG) files are probably the most common digital files. They are "compressed" files, which means that they are smaller files when closed. They open to full size when in use. The compression makes JPEGs easier to send to clients or friends via email, but it also means that you lose some data in the process. JPEGs are commonly used when uploading images to websites or social media sites. JPEGs are "flat" images, meaning you cannot save an image in which you have created different "layers" in a postproduction program as a JPEG. JPEGs are "lossy" files. You re-compress the file each time you edit and save a JPEG, and you therefore

PRO TIPS

▶ File Numbering

Your camera automatically counts the number of images created and assigns a new number in a continuous pattern. If you shoot 517 images on your card and either delete or format your card, then the next image created will be numbered 518. This is fine if you have a system for keeping track of which numbers pertain to which shoots, but personally it would drive me nuts! There is a file numbering or file sequencing menu option that allows you to reset the numbering system to "1" each time you start photographing a new set of images. I create separate folders for each job, so it makes sense for each of my folders to start off at number 1. Some cameras require you to turn this feature on, while others seem to automatically reset the numbering sequence to one. Check your camera manual for information about your camera.

▶ RAW or JPEG?

There is a lot of controversy and discussion among professionals about whether to shoot RAW or JPEG. The big rap against RAW files is the size of the image. I feel that this was a valid argument ten to fifteen years ago when hard drive space was limited and costly. Hard drives these days are huge and cheap, so there is no reason to sacrifice data to "save" space. Another argument was that RAW images were useful to "save" bad exposures in postproduction. The argument was that you did not need to shoot RAW if you were in control over your exposures. I don't see the logic in this argument. RAW images allow you to capture every possible bit of information. The "extra" information is valuable, especially if you have carefully controlled your exposure. I am a complete control freak in the studio. I control my exposures down to $\frac{1}{10}$ stop in most situations. I shoot RAW.

▶ RAW + JPEG

What about shooting RAW plus JPEG? This does use more space, but I still think that there are times when it is appropriate to shoot both formats. One time might be when you want a file to quickly upload to a social media website. A RAW file won't work. The other benefit is the built-in backup (JPEG file) in case the RAW file becomes corrupt.

MENU OPTIONS

▶ Quality/Size

There is a Quality and/or a Size option in your camera's Shooting (or Tools) menu where you can choose your file type and file size. Some cameras (like Canons) have one setting, while others (like Nikons) have two. You can choose to capture RAW, JPEG, or both types of files. If you choose RAW on the Nikon-type cameras, you can no longer choose your file size because RAW is the largest file available. You have more options when you choose JPEGs. You can choose a large, medium, or small (Canon model) or fine, normal, or basic (Nikon model). The size chosen relates to the amount of compression that the camera applies to the file (i.e., how much data is thrown away). The amount of data lost with the smaller JPEGs is significant. For example, a large JPEG might give you an 18-megabyte file, while a medium JPEG will give you an 8-megabyte file, and a small JPEG will yield a 4.5-megabyte file.

lose more data each time. Another drawback to JPEGs is the limited bit depth of the files. JPEGs currently do not support 16-bit files.

PSD (Photoshop Document) files are saved at their full size so they take up much more space on your hard drive. However, PSD files are "lossless" files, meaning that you can edit and save them as often as you need to without losing any data. Images with multiple layers can be saved as PSD files.

TIFF (or TIF) files have the same benefits as PSDs, although I have read that they can be even larger files to store than PSDs. There was a time when TIFF files would not support layers, but they do now. The primary advantage of TIFF files over the PSD format is the number of applications that can open the images. More applications will open TIFF files than PSDs. If you are sending a layered file to a client and you are not sure what programs they have, then save the file as a TIFF.

RAW files are, in my opinion, the "Granddaddy" of all file types. RAW images are very large files, but they capture every bit of information available when the photograph is taken. The major downside is you need a program like Photoshop, Lightroom, or Aperture to open RAW images. There are other ways to open RAW files, but they do have a limited number of applications that support them.

There are many other file types that you will see. There are bitmaps, PDFs, GIFs (used a lot in animated images), etc., but you should be fine using a combination of the file formats discussed earlier.

Compression. In simple terms, compression refers to making a file that is large when open into a small file when closed for storage on your hard drive. The good thing about a compressed file is it takes up less space on your storage unit. The bad thing is that the act of compression destroys or throws away some of the data. There are different compression rates that can be applied to your images. The more you compress a file, the less space it takes on your hard drive but the more data you lose.

Resolution

The resolution of your digital files relates to the number of dots per inch (dpi) or pixels per inch

PRO TIPS

▶ Resolution Requirements

It is the actual number of pixels that ultimately determines whether an image is high or low-res. For example, one of my images measures 2000x3000 pixels, which yields a 6.667x10-inch photograph at 300dpi. The same image would give me a 27.778x41.667-inch photograph at 72dpi. I don't have much use for a 41-inch image at 72dpi, so I keep it at 300dpi to maintain a usable size. I then downsize the file to 10 inches at 72dpi and get an image of 480x720 pixels. Be *very* careful when you resize your images for web use. Make sure you use the Save As, *not* the Save option when you save the new image. Give it a different name so you know which is which. I add "72" to my file names to designate my low-res 10-inch images.

▶ 8 Bit or 16 Bit?

My original edits are always done in the 16-bit mode. I then convert the file to 8 bits for export to whatever final use I have for the image.

(ppi). Simply put, your resolution is the amount of detail in your file, and it determines what you can do with the image. Generally speaking, an image is considered either "high-res" or "low-res." A high-resolution image is generally considered to be 300dpi and is used to make prints or to send to a client for offset printing (magazines, etc.). 300dpi is about as "tight" as you will need, and many print jobs require less than this amount. You can also "blow up" images to poster-size prints when they are high-res. I have prints larger than 36 inches that came from a 10-megabyte file that are beautiful.

Low-res images are generally 72dpi and are used to post on websites and social media sites. Your computer screen resolution is usually 72dpi. You won't get the best results if you print a 72dpi image, and you cannot blow the image up without it becoming a pixelated mess.

▶ **Low-res images are generally 72dpi and are used to post on websites and social media sites.**

Color Channels

Digital cameras capture colors along three main color channels: red, green, and blue. You will often see these referred to as RGB.

Bit Depth. Bit depth relates to how "deep" each color channel is and, consequently, the number of colors depicted. For example, an 8-bit image has 8 "levels" in each of the three channels, so it gives us the familiar 256 colors per channel. (It

▶ **This formula yields 256 shades of red, green, and blue in an 8-bit image.**

is a complicated mathematical formula in which one bit is given a value of 2. The number of colors per channel is obtained by taking the value of 2 and raising it to a value equal to the number of bits as an exponent—2^8 in this case or $2x2x2x2x2x2x2x2$. This formula yields 256 shades of red, green, and blue in an 8-bit image. The possible number of colors is over 16 million ($256x256x256$)! In contrast, a 16-bit image gives us 261 trillion possible colors! (See www.photoshopessentials.com/essentials/16-bit/ for more information on this confusing issue, but for now recognize that you have plenty of colors to work with in either mode.)

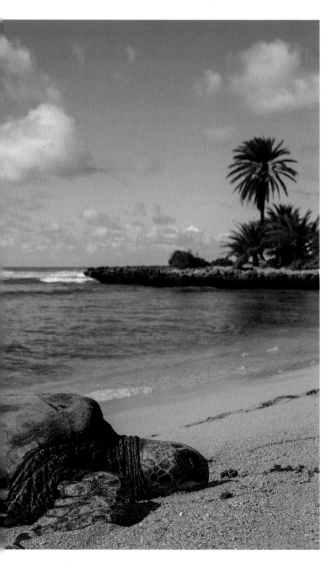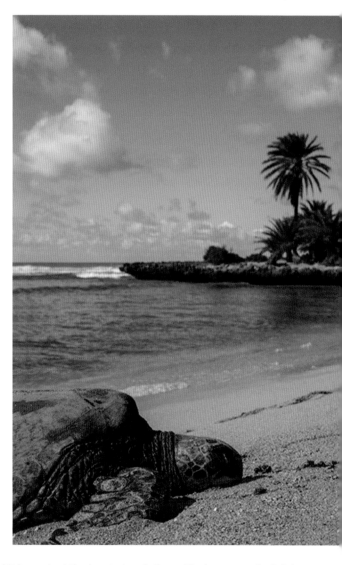

The Hawaiian Giant Sea Turtles are a protected species, and it is against the law to touch them. The image on the left is from a high-resolution file that could be enlarged many times and maintain its quality. The image to the right is from a low-resolution file. It will look fine online, but it does not print very well.

2. EXPOSURE ESSENTIALS

Take another look at the images you shot with the camera set to Auto mode. Your camera evaluated and made a representation of all of the tones and colors in your scene based on the light reflecting back from the various elements in front of your lens. If the camera did a good job, then you will see a range of tones from light to dark that make up the exposure.

Ideally, you will have a range of tones from lighter areas, to what we call neutral or midtone values, to darker sections. It is this range of exposures that create the naturalistic, three-dimensional feeling in the image. Technically, the lighter areas are actually overexposed compared to the midtones and are called your highlights. Darker areas are underexposed and are defined

Your exposure is the range of tones that your camera captures. You want to create images with a solid range of highlights (like the white caps) to shadows (like the dark areas in the shade of the bushes in this photograph of Rabbit Island on Oʻahu). Image by Joan.

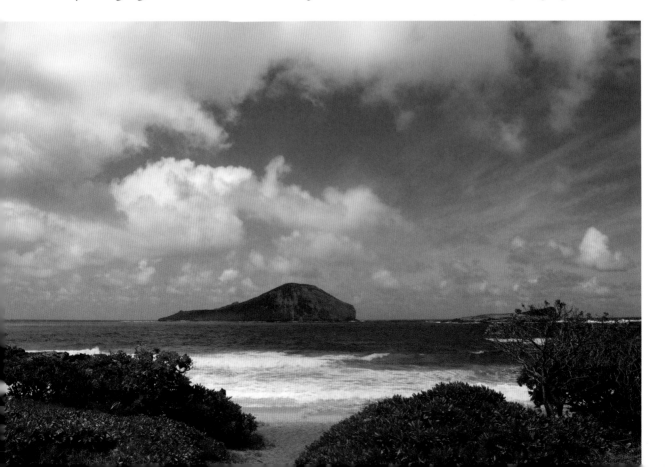

as your shadows. The range from highlights to shadows shows the scene's contrast. If the values in your highlights are extremely different from the values in your shadows, then the scene will have too much contrast to show detail in the brightest and darkest areas. If the values at the extremes are very similar, then you will have a dull "flat" photograph. We will look at this in more detail in chapter 3.

Exposure Controls

So, our job is to create images with a pleasant range of highlights to shadows without letting the image go too bright (overexposed) or too dark (underexposed). How do we do that? What are the controls that we can use to manage our exposure? There are three controls that you will need to know about: ISO, aperture, and shutter speed. The aperture and the shutter speed control and adjust how much light actually gets into the camera and to the sensor. The ISO controls how the camera reacts to the light hitting the sensor. None of this matters right now because your camera is still on Auto mode! Change the mode dial to program (P) and we can start discussing the first of these exposure controls.

The first exposure control is called the ISO. Some of you may know this as the ASA when you shoot or shot film.

ISO. I used to go into a store and buy a roll of ASA 100, 125, 160, 200, 400, 800, etc., film. ASA stands for "American Standards Association," but the number really pertains to the "film speed." A higher ASA film has more light-sensitive materials in the film and can create an image in less light. A high ASA is known as a "faster" film. The same concept is called the ISO in digital photography. ISO stands for "International Standards Organization," and the numbers pertain to how sensitive your camera's sensor is to light. A higher ISO number indicates that the camera is more sensitive to light and can therefore create an image in less light. Remember that while the ISO is one of the three controls that determine your exposure, it has nothing to do with how much light enters the camera. Rather, the ISO determines how the sensor will react to the light. Note that ISO has nothing to do with how much light enters the camera, but rather how your camera reacts to that light.

It may be a little easier to think of what happened with film at different film speeds. Remember that there were actual silver nitrates in the emulsion of film. A lower ASA film (a "slower" film) had less silver nitrate to "grab"

MENU OPTIONS

▶ ISO

Many cameras have a button that allows you to easily access and change your ISO. I sometimes find it easier to access this control via the menu feature (available on some camera models). It doesn't matter how you get there. Find the system that works best for you. Note that you cannot change your ISO if you are shooting in the full auto mode. Most cameras have an auto ISO option. If you leave your camera mode on program mode and set your ISO to auto, then you are essentially still shooting in auto-exposure mode. Some cameras have menu options that allow you to limit the range of ISO numbers that your camera can choose from in auto ISO. Some cameras have a menu option that will allow you to expand the range of ISO numbers that are available for use. You might also see a "Hi" and "Lo" ISO choice. This essentially allows you to shoot at a lower or higher ISO than the respective lowest or highest number indicates.

PRO TIP

▶ Digital ISO Benefits

The ability to change your ISO on the fly is one of the most appealing features of digital photography. We had to shoot the entire roll of film in order to change the ASA when we shot film. You can now change your ISO any time and as often as you wish!

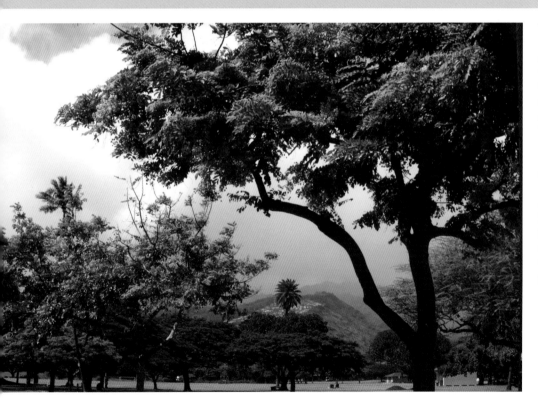

You would set a low ISO when shooting outdoors because there is plenty of light available to capture on your camera's sensor. This image of Kapiolani Park in Honolulu, Hawaii, was captured at ISO 200. You would choose a higher ISO if you were shooting indoors without a flash, like in the volleyball image on page 33.

the light, so you needed more light or needed to allow more light into the camera to get a correct exposure. A "faster" film, one with a higher ASA number, had more silver nitrates to grab the light, so you could get the same exposure in less light.

Let's take a look at a couple of dramatizations. Pretend that each black spot in the images to the right represents something that is capable of capturing light.

One analogy that you can use to further understand what your ISO does is to think of your camera as a dark room with a single window. How much light and time would it take to fill the room with light if we had a large window (high ISO)? We would need a little light because the big window makes the room very sensitive to whatever light is available. Now, how much light or time would we need to fill the room with light if there were a small window (low ISO)? We would need a lot more light and/or time because the room with a small window is less sensitive to the light available. Note that we are not talking yet about controlling how much light comes in the respective windows. Rather, we are talking about how the room interprets or reacts to the light coming in.

Here are the numbers you will likely see when access your ISO controls. The numbers in bold are found on most cameras, while the other numbers are on higher-end cameras:

Lo1 Lo2 Lo3 **100** 125 160 **200** 250 320 **400** 500 640 **800** 1000 1280 **1600** 2000 2560 **3200** 4000 5120 **6400** Hi1 Hi2 Hi3

Take a look at the numbers in bold again. The relationship between these numbers is obvious:

TOP—This diagram represents the light-sensitive material in an ISO with a low number. You would need a certain amount of light to record a particular image with this much light-sensitive material. You would set this type of ISO under bright light conditions.
BOTTOM—This diagram represents the light-sensitive material in an ISO with a high number. You would need much less light to record the same image with the same exposure with this much light-sensitive material. You would set this type of ISO under darker conditions.

each bold number is twice or half of the bold number next to it. Let's look at a couple of examples: If you change your camera from ISO 100 to ISO 200, then your sensor is *twice* as sensitive to light so you could get the same exposure with *half* the light. If you change the ISO from 800 to 400, then your sensor is *half* as sensitive to light and you need *twice* as much light to get the same exposure.

PRO TIP

▶ A Stop of Light

The idea of doubling or halving the ISO leads to the introduction of a very important concept in photography. A *stop* of light is any unit/amount of light used to make an exposure. You change that value by a ***full stop*** when you either double the camera's sensitivity to light or cut it in half. We will talk about how you control the amount of light entering your camera soon. The same concept of a "stop" of light applies when you double or halve the amount of light entering the camera. This idea will make more sense to you as you proceed through the book.

TERMS

▶ Grain

"Grain" has several meanings when it comes to film. Each film has its own grain structure or look. Many photographers would choose one film over another because of the grain structure. A grainy negative has a different connotation. Films with a higher ASA had more of the light-sensitive material in the emulsion. Remnants of these materials stayed in the emulsion after the high ASA film was processed. The remaining grain would then be projected onto the photographic paper along with the image. The tradeoff for being able to shoot in low light conditions was often a grainy negative and print.

▶ Noise

"Noise" is the digital correlate to grain in film. You can raise the ISO of the camera in low-light situations to make the sensor more sensitive to the light that is available. However, there must be enough light reflecting off of your subject to record something. Your camera will literally create specks of red, green, and blue at high ISO settings in the areas where no light is reaching the sensor. This occurs most often in the shadows.

How do you know which ISO to choose? My rule of thumb is to use the lowest ISO I can for any given situation. Why? This is the first opportunity to introduce an idea that will become a familiar theme as you gain a greater understanding of your photography: there is always a trade-off in anything you do! There is no problem when you are shooting in bright areas or with a flash. You can set a low ISO in these situations and get beautifully clear images. The advantage of a high ISO is the ability to shoot in low-light situations without a flash.

The trade-off to being able to capture images with this type of ISO is increased "noise" with digital capture. "Noise" refers to visible specks of color that junk up your image. This is known as "grain" when you shoot film. We would occasionally shoot a high ASA film to get that grainy look for a particular purpose, but I don't see any reason or benefit to purposely shooting an image with a lot of noise.

How much noise is too much? When does the amount of noise present make it not worth taking the photo? That is a personal

ASSIGNMENT 2

Fill in the following chart:[1]

Original ISO	Change to	Sensitivity Change	Light Needed for Same Exposure
1600	800	$^1/_2$ as sensitive to light	X
100	400	X	$^1/_4$ the amount of light
X	1600	Twice as sensitive to light	$^1/_2$ the amount of light
3200	X	$^1/_4$ as sensitive to light	4 times the amount of light

1. Key: Twice the light, four times as sensitive, 800, 800.

My rule of thumb is to start with the lowest ISO I can to limit the amount of digital "noise" in my image. This image of Diamond Head was captured at ISO 400. ISO 400 is still a relatively low ISO, so noise would not be a concern.

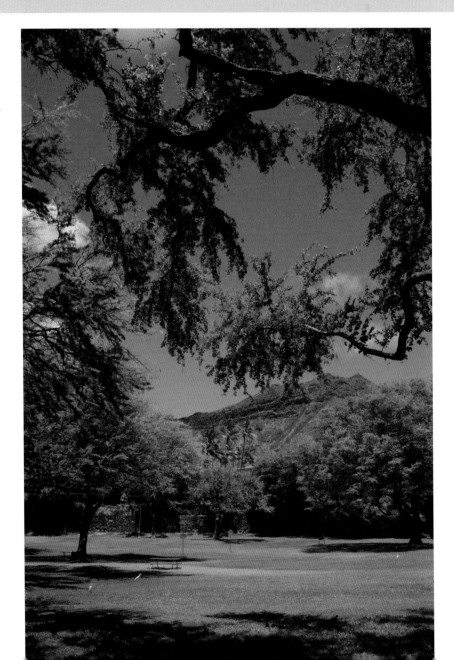

MENU OPTIONS

▶ High ISO Noise Reduction

Many cameras have a menu option tucked away called "High ISO Noise Reduction." Note that it is called noise reduction not noise removal. The noise-reduction feature essentially blends the specks together rather than keeping them visible as clear dots. My joke in my classes is that you have a choice between clear dots and mud! There is also a long exposure noise-reduction feature on many cameras.

PRO TIP

▶ Camera Upgrade?

It seems camera companies are coming out with new digital camera models every few months. The good news is that each generation of digital cameras does a better job of reducing high-ISO noise. Many people flock to the latest and greatest camera version because of the increased file size (more megapixels). Megapixels are important to a degree, but I think the way the new camera sensors are handling noise reduction is a much more important reason to upgrade your gear than a few extra megapixels, especially if you are shooting in primarily dark environments without a flash.

question, but I had a recent experience that might shed some light on the topic (no pun intended). I was in the Philippines visiting my then girlfriend. We got engaged on this trip and stayed in Bohol. Bohol was home to many beautiful ancient churches dating back to the 1500s. We toured several of these historic buildings and shot the interiors with very a high ISO. Disaster struck Bohol a year later in the form of a 7.2 earthquake. All of the old churches that we visited were destroyed. The photographs were very noisy and have limited commercial use, but we have the images to remind of us of the churches we saw on the trip during which we got engaged.

Aperture. Your aperture is the size of the lens opening that controls the amount of light that comes down your lens and enters the camera when the shutter is open. Your aperture is one of the three things that control your exposure. A large lens opening (aperture) allows

There were times when we would choose a film with a high ASA to create an image with a grainy look. The grain helps to set the mood in this stoic portrait of Michele Ivey. The sepia tone was added in Photoshop.

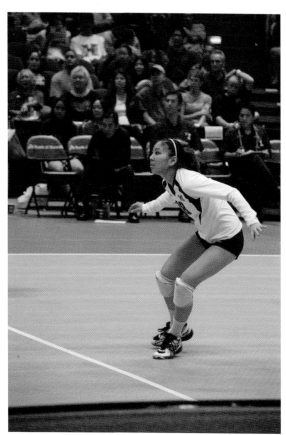

LEFT—This in-studio portrait of former University of Hawaii Wahine Volleyball standout Jayme Lee was created at ISO 100. Notice the smooth, clean look of the image.

RIGHT—Here is a photograph of Jayme on the court. Our eyes can fool us because we see so many more shades of light than a camera does. The Wahine play on the UH Campus at the Stan Sherriff Center. Believe me, it is bright inside the arena—but not bright enough to capture this image with the lens I had without increasing the ISO. This was shot on an older model camera at ISO 1600. Notice the specks of color, especially in the shadows.

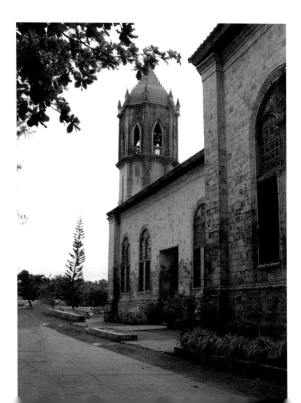

LEFT AND ABOVE—These photographs of a very old church in Bohol, Philippines, are all that remain after the church was destroyed in an earthquake. The image of the interior is noisy because it was shot at ISO 6400, but we are glad to have a memory of our time in this piece of history that no longer exists. This image is proof that while the photographs may have limited uses, it is better to create an image with a lot of noise than not to have the images at all.

ASSIGNMENT 3

Find out how to change the ISO setting on your camera. Find a fairly bright area and set your ISO to the lowest-possible setting. Shoot ten images using the program setting. Next, set your ISO to a middle value and shoot ten images on the program setting. You'll probably have to move to a darker location for this part, but now set your ISO to the highest value and shoot ten images on the program setting. You'll examine the other exposure values captured later on. For now, open a few images from each setting. The photos should look approximately the same in terms of lightness/darkness, but look at the overall quality. The images shot with the highest ISO settings will look "fuzzier." This has nothing to do with the sharpness of the image. The loss of quality has to do with the increased noise due to the high ISO setting. Your image will be particularly "noisy" in the darker areas. Your camera might have a menu option called "Noise Reduction." If it does, then you can set it to "High-ISO Noise Reduction." This might help, but it won't eliminate the noise.

PRO TIP

▶ F-Stop Numbers and Aperture Sizes

The f-numbers are counterintuitive to the actual size of your lens opening. The smaller numbers represent bigger openings that allow more light into your camera, like wide-open blinds let more light into your room at home. Larger numbers are small openings that let less light into the camera, like tightly closed blinds on your windows.

more light to enter the camera when the shutter is open than a small opening.

F-stop. In some ways, the term "f-stop" is synonymous with "aperture." The terms are often used interchangeably. However, there are some differences. The f-stop is a numerical value assigned to the size of your lens opening. There is an inverse relationship between the f-number and the size of the lens opening (a higher f-number equates to a smaller lens opening). We will go more into what these numbers mean in a little while.

You can easily change your f-stop in either manual mode or aperture-priority (A or Av) mode. Many cameras give you the option of choosing $\frac{1}{3}$ or $\frac{1}{2}$ stop increments for your f-stops. The default on most cameras is $\frac{1}{3}$ stop increments.

Here are some common f-numbers that you might see (based on $\frac{1}{3}$ stop increments):

1.8 **2** 2.2 2.5 **2.8** 3.2 3.5 **4** 4.5 5 **5.6** 6.3 7.1 **8** 9 10 **11** 13 14 **16** 18 20 **22** 26 28 **32**

The numbers in bold are commonly known as full f-stops, although the relationship between all of the numbers is exactly the same. It does not matter where you start on the line: three "clicks" in either direction equals a one-stop difference—doubling or halving the amount of light entering the lens—if your camera is set on $\frac{1}{3}$ stop increments.

Your aperture is a mechanism that was historically in the lens, but nowadays it is mostly controlled by your camera. Your lens

opens in varying degrees to allow different amounts of light into your camera. Remember the idea of your camera as a dark room with a single window, described earlier. The window now comes with an adjustable set of louvers or blinds that allow light to come into the room at varying amounts. A slight break in the louvers allows a very little amount of light in the room. Opening the louvers all the way floods the room with light. Your aperture is like the louvers on the window. A very small opening allows a small amount of light into the camera. A large opening floods your camera with light.

Let's take a look at how an aperture works.

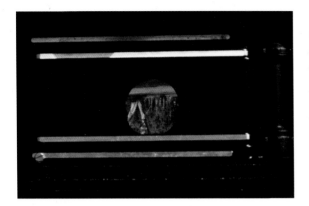 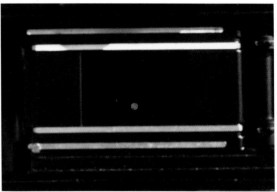

LEFT AND RIGHT—The aperture is the diameter of your lens opening. It is the hole that allows light into your lens. One of the drawbacks with the digital camera today is the inability to open the back of the camera and see what we are talking about. These images are of an old Canon F-1 film camera with a 100mm lens attached. The bigger opening, f/2.8 (left), allows more light into the camera than the smaller opening on the right (f/22). Notice that the trees that are visible in the left-hand image are upside down. We discussed this phenomenon on page 9. Light travels in straight lines, so what is recorded at the bottom of your image is actually the top of your scene!

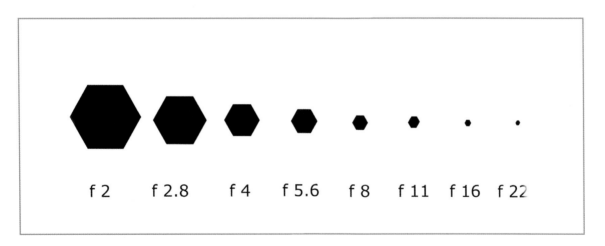

Each aperture is exactly half or twice the area of the one next to it and allows half or twice the amount of light into the camera.

ASSIGNMENT 4

Set the camera on aperture priority. Set your ISO to a number that is appropriate to how much light is available (high number for a darker environment and low number for a bright area). Take one photograph of a close-up subject and one farther away at each full f-stop. Make sure that each scene has a distinct area in front of and behind what you focus on. Notice the differences in how much appears to be sharp in your image. We'll discuss this later.

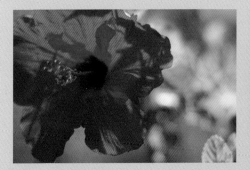 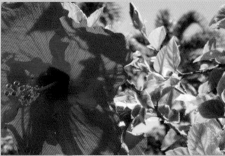

The image on the left was shot at f/2. You will notice that only the petal of the hibiscus is in focus. The image on the right, in contrast, was shot at f/22. There is a lot more in focus in this photograph. We will discuss this more later.

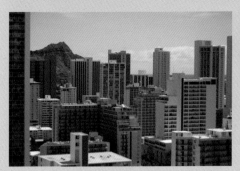 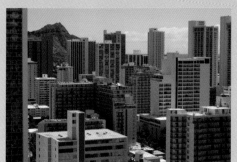

There Is still a difference in depth of field when you shoot images at various f-stops when the subjects are further away. The image of Waikiki on the left was captured at f/2, while the image on the right was shot at f/22. We will see a whole series of hibiscus shots and other Waikiki images later. Those images will show how each f-stop affects the depth of field.

Find the exposure data in your EXIF screens. You will notice how the shutter speed value has changed too. Write down the shutter speed values (these will most likely be fractions) that correspond to the different aperture values that you have selected. Don't worry yet about what those values mean—we'll go over all of that in a little while. Your grid will look something like this:

ISO (whatever you choose; ISO 100 was used for demonstration only)	F-stop (set the camera to the following values)	Shutter speed (get this number from the playback screen on your camera)
100	5.6	X
100	8	X
100	11	X
100	16	X
100	22	X

Shutter Speed. Remember the dark room with the louvers in front of the window? Now imagine that there is a light-tight door in front of the window that opens and closes at various speeds. That door is your camera's shutter, and how fast or slow it opens and closes is your shutter speed. Your shutter speed controls how long the door stays open to allow the light to come through your louvers (aperture) on whatever sized window you have (ISO). A slow shutter speed will let more light in and will show more motion blur. A fast shutter speed lets in less light and stops more action.

The following chart shows a small section of some common shutter speeds:

30″ 25″ 20″ 15″ 13″ 10″ 8″ . . .

$^1/_8$ $^1/_{10}$ $^1/_{13}$ $^1/_{15}$ $^1/_{20}$ $^1/_{25}$ $^1/_{30}$ $^1/_{40}$ $^1/_{60}$ $^1/_{80}$

$^1/_{100}$ $^1/_{125}$ $^1/_{160}$ $^1/_{200}$ $^1/_{250}$ $^1/_{320}$ $^1/_{400}$ $^1/_{500}$

$^1/_{640}$ $^1/_{800}$ $^1/_{1000}$

Note: The inches mark means seconds, so 8″ is a shutter speed of 8 seconds, while 8 by itself is $^1/_8$ second. You might see $^1/_8$ when you look at the shutter speed on the LCD screen, but you will probably see just the 8 when you look through the viewfinder to see the exposure data. It is best to get used to seeing and adjusting your controls while looking through the viewfinder.

The numbers in bold can be thought of as whole shutter speeds, just like with the f-stops. Each bold number is exactly twice as fast or twice as slow as the one next to it. This concept will sound familiar by now: each bold number is one full stop faster or slower than the one next to it because it lets in exactly half or twice the light as its immediate neighbor. My old "antique" film camera had only whole shutter

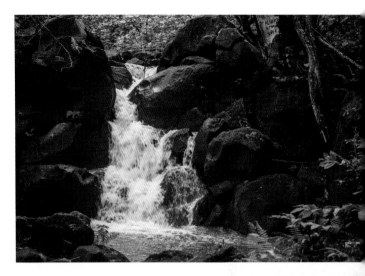

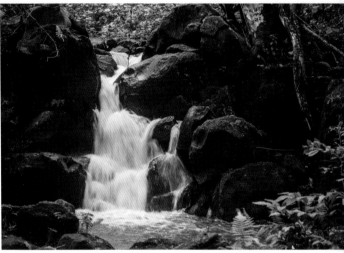

Your shutter speed is one of the three factors that control your exposure: longer shutter speeds allow more light to enter the camera while shorter speeds allow less light into the camera. However, there is a creative aspect to choosing a shutter speed. You decide how you want to show motion in your photographs by changing the shutter speed. A shutter speed of $^1/_{60}$ second is fast enough to begin to freeze the water coming down this "secret" waterfall on the island of Kaua'i in Hawaii (top), while a shutter speed of $^1/_{10}$ second creates the creamy, blurred look in the water (bottom). There is no "correct" choice. It is your decision as a photographer.

speeds, but modern cameras give you more options. The other numbers are intermediate speeds and again, like your f-stops, reflect $\frac{1}{3}$ stop increments. Three "clicks" on your shutter speed dial will give you a one-stop difference in exposure if your camera is set for $\frac{1}{3}$ stop increments.

There is a special shutter speed option called "B" or "Bulb." Your shutter will stay open for as long as you hold the shutter release button down. Use the bulb setting for exposures longer than 30 seconds, perhaps for a time-lapsed image at night. Note, however, that you can get noise from long exposures similar to what you get at high ISO settings. There is a long exposure noise reduction setting on most cameras.

You can set your shutter speed in either manual mode or the shutter-priority mode (S or Tv). The same dial that you used to change your f-stop in the aperture-priority mode will adjust your shutter speed on most cameras.

You may be wondering why you've been writing all these different values down—after all, the image densities all look fairly consistent. Well, the image densities are fairly consistent because:

A.) When you selected the program mode and changed the size of your window (ISO), your camera changed either the size of your louver opening (aperture) and/or the speed at which your door opened and closed (shutter speed)

ASSIGNMENT 5

Set your ISO on the lowest-possible setting and go outside. Set the camera on shutter-priority mode and shoot something that is not moving: a pole or a table is good. Start with a shutter speed of $\frac{1}{125}$ and take a photo. Adjust the shutter speed three clicks (one stop) to $\frac{1}{60}$ second and take the same photograph. Keep going down until you notice that some of your images are blurry. We'll discuss this later. Don't worry if some of the images start to get lighter. We'll get to that as well. Find the exposure data in your EXIF screens. You will also notice how the aperture value has changed. Write the aperture values that correspond to the different shutter speeds that you have selected.

Your grid will look something like this:

ISO	Shutter Speed	F-Stop
100	$\frac{1}{125}$ second	X
100	$\frac{1}{60}$ second	X
100	$\frac{1}{30}$ second	X
100	$\frac{1}{15}$ second	X
100	$\frac{1}{8}$ second	X
100	$\frac{1}{4}$ second	X

Sugar and pineapple plantations ruled the Hawaiian economy from the mid-1800s to early 1900s. Railways were used to transport the produce. The rails and the majority of the plantations are long gone—except for a small and fascinating museum in Ewa on O'ahu. It is a yard full of great old relics; even the wood between the tracks is breaking up! This was my favorite of the trains, and you will see her again in our discussion of lens focal lengths. The point of these five images, though, is to show how much difference there is in one stop of light. Image 3 was the properly metered image and shows a nice tonal range from the dark engine to the white clouds. Images 1 and 2 were each overexposed by one stop respectively. Details in the highlights are already starting to blow out at one stop over (image 1), and the whites are gone at an exposure of two stops over the "proper" settings (image 2). Notice also how the blacks are middle gray in the far-left image. It isn't any better when you underexpose the image by a stop or two (images 4 and 5). The point is that you have to be extremely careful with your exposures with digital photography.

B.) When you set your ISO and chose the aperture-priority mode, your camera changed your shutter speed (the door) as you changed your aperture

C.) When you set your ISO and chose shutter-priority mode, your camera changed the aperture (the louvers) as you changed shutter speed.

Why were these changes necessary? Most of the images that you created for the last few assignments had pretty consistent exposures, even though you were changing one of the controls that monitor how light is recorded. Changing one of the three controls introduced above will change how much light gets into your room or the room's sensitivity to the light getting in. For example, you would get a brighter room if you kept the louvers open the same amount and opened and closed the door at the same speed but had a bigger window. In camera language, this would be keeping your f-stop and shutter speed the same while increasing the ISO. You would get a darker room if you had one sized window, a consistent louver opening, but opened and closed the door faster. In camera language, this would be shooting with a faster shutter speed while keeping the ISO and f-stop the same. We introduced the concept of a "stop" of light when we first discussed ISO. The images above show how much light one stop represents.

The tonal density of these images (page 39) changed with each photograph because the camera was set on manual mode. The camera is on vacation now. It is not going to compensate the exposure for you. It is all up to you. You can set your ISO the same way you have been, even in manual mode. The way you set your shutter speed and f-stop depends on your camera. You might need to check your specific camera manual to learn how to do this, but DSLR cameras will generally follow a standard procedure. Most DSLR manufacturers produce cameras with varying levels of options. Don't worry, the higher-end cameras may have more bells and whistles, but the entry-level cameras are just fine. I own both, and it is almost impossible to tell which image or video came from which camera.

Anyway, the entry-level cameras tend to have one dial that is used to scroll through all of the controls. This dial will control your shutter speed when you are working in manual mode. Look for either an "AV" button (not the AV on the mode dial) or a +/- button on your camera. Hold this button down and turn the dial to change your f-stop. The higher-end cameras tend to have two dials. One of these dials will control your shutter speed and the other will change your f-stop.

ASSIGNMENT 6

You will now go out and create some bad photographs (on purpose) and discover the relationship between "stops" of light. Go outside on a bright day and set and leave the ISO at the lowest-possible setting. Set the camera on aperture-priority mode, set your camera to f/11, and take a picture. Find the EXIF data and note the shutter speed. Change the mode to manual and set the shutter speed and f-stop to the settings you just wrote down. Take a photograph—yes, the same photograph you just shot. Now change your f-stop by a full stop (usually three "clicks" of the aperture dial) in either direction and take a photograph. Do it again and again until you run out of f-stops. Now go back to your original settings and go in the opposite direction and compare the results. Now go back to the original settings and shoot the same thing at several full shutter speeds. Compare the results. Now go back to the original settings and shoot the same thing, changing your ISO by a full stop each time. Each image will be a good deal lighter or darker than the one before it. That is what one stop of light is! You may have seen this with assignment 4 if your camera ran out of room to adjust the f-stop as you changed your shutter speed.

3. CONTROLLING EXPOSURE

More About F-Stops

We will now begin to explore how *you* can make the exposure adjustments that your camera made for you at the different "priority" modes. However, we need to expand on the idea of f-stops. We said before that on one level, the term "f-stop" is equivalent to "aperture." However, "f stop" has a much deeper meaning. We are going to get into lenses and how they work in a while, but one thing that you will notice quickly is that each lens has the same set of unusual numbers. The numbers correspond to how wide the lens is open (how much the louvers are opened). The beauty of f-stops is the consistency from lens to lens. It does not matter whether you have a 50mm lens, a 100mm lens, or a 200mm lens: f/8 is f/8 is f/8. How is that possible? We have all seen a hallway with

one light. The hallway gets darker as you move farther from the light, right? This is because light fades as it travels. The same thing happens as light travels down your lens: it fades as it travels and would provide less light to your sensor with a longer lens if f-stops represented the actual absolute diameter of your lens

Exposure control is the most critical technical aspect of photography, especially with a medium like digital capture in which you lose critical data at even two stops over and underexposed. This image of Kristen Stephenson Pino was shot in full manual mode after careful metering and adjusting all of the lights.

TERMS

▶ Focal Length
The focal length of your lens is equal to the millimeter distance that light travels from the outer element of your lens to the sensor.

Focal Length of Lens	Actual Diameter of Lens Opening	F-Stop
50mm	25mm	2
50mm	12.5mm	4
50mm	6.25mm	8
50mm	3.125mm	16
100mm	50mm	2
100mm	25mm	4
100mm	12.5mm	8
100mm	6.25mm	16
200mm	100mm	2
200mm	50mm	4
200mm	25mm	8
200mm	12.5mm	16

opening. The numbers are the same from lens to lens because they are not absolute numbers. Rather, they are ratios.

Lenses come in different focal lengths, so the actual size of the aperture opening will change from lens to lens at the same f-stop. However, the ratio between the actual size of the opening (the diameter) to how long the lens is remains constant across lenses. For example, one of the numbers that you might see is f/4. The actual diameter f/4 would be 12.5mm if the lens measured 50mm but would be 25mm on a 100mm lens. The size of the opening is different, but the ratio, or f-value, is the same.

Another initially confusing aspect of f-stops is the inverse relationship between the number and the size of the lens opening: larger numbers represent smaller diameters. This makes more sense when you remember that we are talking about ratios, not absolute numbers. The ratio is:

Focal length/actual diameter of your lens = f-stop. The f-stop is simply the number of times that the diameter of the lens opening divides into the focal length.

Let's look at a chart that shows some examples of both of these phenomena. We will look at every other f-stop because the math is easier to show.

The chart above shows the two main components of f-stops: (1) The actual size of the lens opening varies from lens to lens, but the ratio remains the same; and (2) Regardless of the lens, the f-number gets larger as the actual lens opening gets smaller because the ratio between the opening and the focal length changes in predictable and consistent ways.

Variable f-stop lenses are zoom lenses in which the maximum f-stop (lowest number) changes as you change focal lengths. You can tell if your lens is a variable f-stop lens by

looking at the front of the lens. If the lens says something like f/3.5–5.6, then it is a variable f-stop lens. The actual largest opening of the lens is the diameter of the larger f-number at the telephoto focal length. The lens manufacturers play with the ratio of the focal length to the actual diameter of the lens opening. Let's say that the lens is a 17–55mm zoom. The actual largest diameter of the lens opening is equivalent to f/5.6 at 55mm. The diameter of the lens does not change as you change the focal length to wide angle (17mm). The same amount of light is entering your camera, but it is traveling a shorter distance. Therefore, the light hitting the sensor acts like a larger lens

PRO TIP

▶ **Metering and Variable F-Stop Lenses**

Be careful when using variable f-stop lenses in manual mode at f-stops larger (smaller numbers) than f/5.6. You have to control your exposure in manual mode. The quantity of light hitting your sensor will change as you change focal lengths and your exposure will be based on your focal length. This is only true for the largest lens opening. For example, if you shoot at the maximum telephoto focal length and get a reading of f/5.6, then your exposures will be consistent only if you stay at that focal length. If you decide to shoot at a wider angle, thereby shortening the distance that the light travels, then you will overexpose your image if you do not re-meter at the shorter focal length. We will cover shooting in manual mode soon.

opening. In this case, the actual diameter of the lens is the constant in the f-stop ratio, while the focal length is the variable.

Exposure Equivalents

The tonal values in your photographs stayed relatively stable in assignment 3 when you shot in the aperture-priority mode. They also stayed relatively stable in assignment 4 when you shot in the shutter-priority mode. However, they changed dramatically when you only altered the f-stop, ISO, or shutter speed in assignment 5 while shooting in manual mode. The camera compensated for you when you made changes to your controls in the priority modes. Go back and look at the charts you made for assignments 3 and 4. In assignment 3, you set your ISO and changed your f-stop, allowing different amounts of light to enter the lens. Your camera changed the shutter speed to compensate for the differences. The opposite occurred when you worked in the shutter-priority mode. You set the ISO and changed the shutter speed, also modifying the amount of light entering the camera. The camera chose an appropriate f-stop to compensate until it ran out of f-stops.

However, your exposures were variable when you changed only one control in manual mode. You have to compensate for these changes by moving one or both of the other controls in the opposite direction if you want to maintain the same exposure; your camera will not do it for you. For example, let's say that an image is properly exposed at f/8 at $\frac{1}{60}$ second and ISO 800. If you changed the aperture to f/11 (smaller opening), then you would have a darker image unless you changed the shutter speed to compensate. The shutter would need to be open longer to compensate for the lower

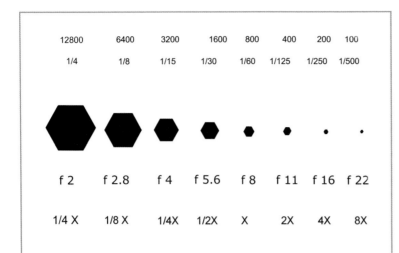

12800	6400	3200	1600	800	400	200	100
1/4	1/8	1/15	1/30	1/60	1/125	1/250	1/500
f 2	f 2.8	f 4	f 5.6	f 8	f 11	f 16	f 22
1/4 X	1/8 X	1/4X	1/2X	X	2X	4X	8X

The top row of numbers in the grid represents the ISO. The second row represents shutter speeds while the third row shows f-stops. The last row represents the relative amount of light needed to compensate for changes in any control based on the completely arbitrary selection of ISO 800, $1/60$ second, and f/8 as a "proper" exposure.

amount of light entering the camera through the smaller lens opening.

How much light are we talking about and how do we know how much to compensate? Fortunately, all of the controls are in the exact same proportion to each other. The adjacent "whole" f-stops are exactly one stop bigger or smaller than each other. The "whole" shutter-speed settings are also exactly (or close to) proportional as well. Your ISO settings work in the same way. An ISO of 200 is twice as sensitive as ISO 100. An ISO of 400 is half as sensitive as ISO 800.

All of the numbers in this grid go from more light/sensitivity on the left to less light/ sensitivity on the right. Any change in one control to the right allows less light to hit your sensor or makes the sensor less sensitive to the light. You have to adjust one or both of the other controls to the left to compensate if you want the same exposure. Conversely, any change in one control to the left allows more light to hit your sensor or makes the sensor more sensitive to the light. You have to adjust one or both of the other controls to the right to compensate if you want the same exposure (we will talk about when you don't want the same exposure later).

I think it is helpful to talk the process through. For example, our original exposure was f/8 at $1/60$ second at ISO 800. We want to change the f-stop to f/11. This is how you would think it through: "I changed the aperture from f/8 to f/11, so I made the opening of my lens half as big. I am letting in less light. How much less? I am letting in one stop less light. I have to *either* compensate by letting more light in with my shutter speed *or* make my camera more sensitive to the light by one stop. Okay. I can change my shutter speed to open and close slower by one stop and set that at $1/30$ second (the shutter opens and closes one slop slower and allows one stop more light to get in the camera) *or* I can change my ISO to 1600, which makes the sensor one stop more sensitive to the light coming into the camera." What if you go in the opposite direction and choose f/5.6? You will double the size of the lens opening so you will need to open and close the shutter twice as fast to compensate ($1/125$) or cut the ISO to 400.

Here's where it gets trickier: What if we go from f/8 to f/16? Well, f/8 to f/11 is one stop *and* f/11 to f/16 is one stop, so the change from f/8 to f/16 is two stops. You have reduced the aperture size by two stops, so the image will be considerably darker. To obtain an equivalent exposure, you would need to choose a slower shutter speed to allow more light into the camera and/or adjust the ISO (increase the ISO to make the camera more sensitive to the light) by a total of two stops.

Why would you want to take control over these settings when the auto mode will give you an arguably good image? Well, the aperture and shutter speeds have different effects besides exposure on how your image looks. You have no control over these choices when you are working in the auto or program mode. Understanding these fundamental differences is the key to moving from picture taker to image creator! You can use your aperture or shutter-priority modes to work with the creative applications in the next chapter, but we will also show you when and why manual control outshines even these "better" auto modes.

The summit of Mauna Kea on the big island of Hawaii is ranked among the best places in the world for astrological research. This image of an observatory at sunset was captured in manual mode. You simply would not get these tones with any of the auto modes.

ASSIGNMENT 7

Let's practice with a few problems (we'll leave the ISO alone for a while). The base exposure for these examples is f/11 at $^1/_{125}$ second. We are going to change either the shutter speed or the f-stop. Your job is to solve for X:[2]

f/X at $^1/_{250}$
f/4 at $^1/_x$
f/X at $^1/_{30}$
f/16 at $^1/_x$

2. Key: f/8 at $^1/_{250}$; f/4 at $^1/_{1000}$; f/22 at $^1/_{30}$; f/16 at $^1/_{60}$.

4. CREATIVE APPLICATIONS

Controlling Depth of Field

Light passes through many things in the environment on its way to our sensor. One of the most important things that light passes through for photographic purposes is glass. We focus our lenses by bending the light rays that pass through the glass elements in the lens. How does this happen?

Light rays are bent by the particles of the translucent materials and change direction while passing through. This phenomenon is known as "refraction," and it is the basis for how lenses work. Glass is denser than air, so light slows down and changes direction as it passes through glass. Lenses work by using a series of glass elements to bend the millions of random light rays that enter into a single point. This point becomes the focal point, or the spot of sharp focus in an image. Light will resume its original speed and trajectory once it passes through a denser substance, so your image goes back out of focus once the light begins to regain its inherent speed.

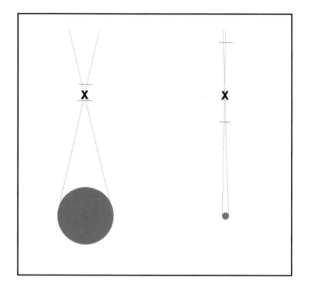

Think of your aperture as the large part of a cone. More light rays are entering the camera at the bigger openings. All these crisscrossing and overlapping light rays need to be bent into a sharp focal point. There is really only one focal point or focal plane, but the narrowing lines of the cone represent the image getting more and more in focus as the light rays converge. Large f-stops create a cone with a more obtuse angle where the light rays converge right before the focal point. The angle created by smaller angles is more acute, so the lines of the cone converge much sooner, with more of the image appearing to be in focus.

PRO TIP

▶ Hyperfocal Distance

There is a distance from your lens called the hyperfocal distance where everything in the background will be in focus. In contrast, there is also a distance from your lens where you are too close to bring your subject into focus. The latter is what is happening when you push the shutter button and the lens keeps moving back and forth making strange "vvvvvvvvvvvvvvv" sounds! Back up a little, and you should be fine.

Everything from the shoreline back in this image of Mystery Island, Fiji, is in sharp focus despite a relatively wide f-stop of f/5.6.

TERMS

▶ Depth of Field

Depth of field refers to how much of your image is in relatively sharp focus when viewed by the naked eye at a reasonable distance. It is the amount of the foreground and background that appears sharp in addition to the focal point. Two things control depth of field: your f-stop and the physical distance from your subject.

▶ Focal Point/Plane

Your lens has one primary job: to bend the light rays that enter it into a sharp point or plane of focus. Your focal point is the part of the scene that you choose to be in sharp focus.

▶ Foreground and Background

The foreground of your photograph is everything that is in front of your focal point. The background of your photograph is everything behind your focal point.

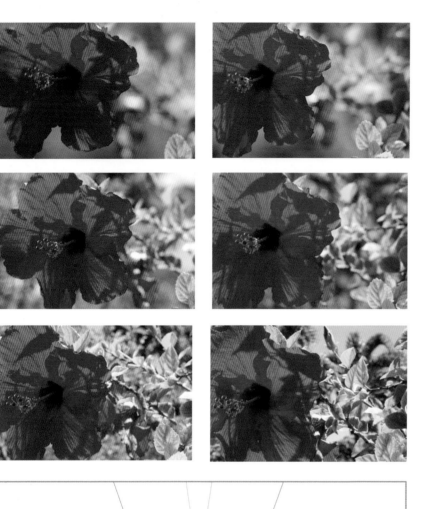
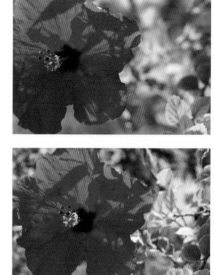
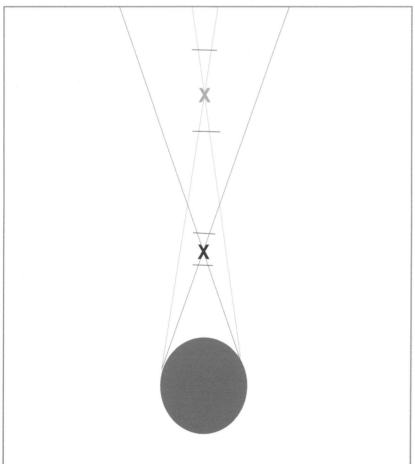

We saw two of these images earlier. Here is the whole series shot at each full f-stop from f/2 to f/22. Smaller f-numbers (corresponding to larger openings) will give you an image with less foreground and background in focus, creating what is called a shallow depth of field. One term for using a shallow depth of field to emphasize part of your scene is "selective focus." The small area of sharp focus within an image that is mostly out of focus will draw your viewer's eyes to the point of interest. Large f-numbers (corresponding to smaller openings) will give you an image with more of your foreground and background in focus, creating an image with a deep depth of field.

The other factor that determines how much of your image is in focus is the physical distance between your lens and the subject. You will have less in focus as you get closer to your subject. In this case, the mouth of the cone (f-stop) is the same size, but you give the lens more time to gradually converge the sides of the cone into the focal plane as the distance increases.

Let's look at some examples of how your f-stop controls depth of field. Go back and look at the images that you created using the aperture-priority mode. Pair them up with the values that you wrote down. What do you notice? You should see a difference in the amount of the image that is in sharp focus: you will see differences in your depth of field. Compare the flower images on page 48 to your own photographs.

These images of Angelyne were shot at f/4. The only difference among these photographs was the physical distance between the camera and our model. The background is more out of focus as we moved the camera closer to Angelyne. The images were created with a beauty dish with the sun streaking through the trees for a hair light.

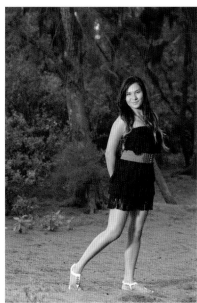

PRO TIPS

▶ Depth of Field Preview

Some cameras have an A-DEP mode that allows you to preview the depth of field before you create the image.

▶ Clearing Up a Misconception

You might read or hear somewhere that you can change your depth of field by changing the focal length of your lens. This is not true. Changing your focal length has no impact on depth of field. It is true that a wider-angle lens will have a smaller actual aperture diameter (see the chart on page 42), which might lead someone to think that it would yield a wider depth of field, but remember, the ratio between the lens opening to the focal length has not changed. Physically moving the camera and/or changing your f-stop are the only two ways to alter depth of field.

My students often comment that they do not see a difference in depth of field with a change in f-stop when they are focused on something farther away from the camera. Distance is such a major factor that it may appear to override the effect of the f-stop. However, this series of the Ala Wai Canal in Waikiki leading to Diamond Head shows that your f-stop still has an impact even when focusing on things in the distance. Notice how the tree in the foreground and Diamond Head in the background appear sharper as the lens opening gets smaller from f/2 to f/22.

Image 1, a fountain in front of Diamond Head in Honolulu, Hawaii, was shot at a focal length of 28mm. For image 2, the same fountain was then photographed from the exact same spot at a focal length of 135mm. Image 1 was shot with a wide-angle lens. It looks like it has a greater depth of field because there is more in the scene and the components are smaller. However, we see that the depth of field is the same when we enlarge part of the image (image 3) to match the field of view and magnification captured with the telephoto focal length. We will talk more about lenses and focal length in little while.

ASSIGNMENT 8

You want to create an image of some flowers that show only the center petals in sharp focus. Set your ISO to fit the amount of light in the scene. Put the camera on aperture-priority mode and take a photograph at f/11 to set the base exposure. Write down the combination of ISO, shutter speed, and f-stop. You will use this information to create the images that you want. Change the mode to manual. Set the camera to the values that you just wrote down. Take another photo with these settings (yes, the same shot you just took!). What two things can you do to create an image with a shallow depth of field and use selective focus to emphasize the flower petals, while maintaining the proper exposure? Go do them and take note of the results.[3] Take your photo and then take a big step backward and take the same photograph. Repeat this three or four times to really get a feel for how distance affects depth of field. Reset your camera to the settings that you wrote down earlier. Now you are at a beautiful location and want to show your family as part of the scene and keep as much as you can in focus, while maintaining a proper exposure. What can you do? Go do them and take note of the results.[4]

3. Key: You want to be as close as you can to your subject and set your f-stop to the lowest number/biggest opening that you can. Adjust the shutter speed to allow less light in or lower the ISO.

4. Key: You want to set your camera on the highest f-number you can and be far away from your subject. Adjust the shutter speed to allow more light in or raise the ISO.

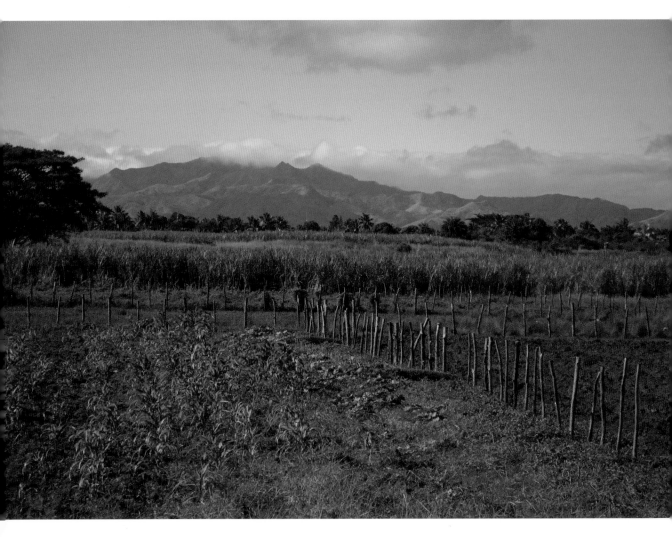

Controlling Motion

What about your shutter speed? Why would you want to control
that aspect of your photography? We mentioned this briefly
when we introduced the idea of shutter speeds. Your shutter
speed controls how much motion is visible in your image. Your
image is exposed for only the amount of time that your "door"
is open. A fast shutter speed allows only what happened during
that short amount of time to be recorded. A longer shutter speed
records everything that happens—or moves—during the time
that the door is open. There are at least two reasons to know
how to control your shutter speed. The first reason is practical:
You probably got some blurry images when you completed
assignment 4. There will be a point when you will not be able

This beautiful farm in Nadi, Fiji,
was shot at $^1/_{3200}$ second. Why
would I choose such a fast shutter
speed to photograph a scene that
wasn't moving? Well, the farm
wasn't moving, but the taxicab I
was in as we passed the farm was!
Your shutter speed controls how
you show motion in your images.

to hand-hold your camera and capture a sharp image. Your subject might not be moving, but none of us can hold perfectly still for unlimited amounts of time, and the amount that we move results in what is called camera shake. The impact that hand movement/camera shake has on the image will vary from person to person and lens to lens. My hands shake more than many people's hands, so my images will be blurrier at a faster speed than will an image

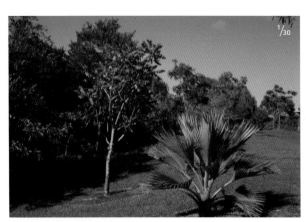

My "limit" with this lens under these conditions is about $^1/_{60}$ second. You can see some movement in the image shot at $^1/_{30}$ second, and the image shot at $^1/_{15}$ second is really bad. Notice also that the image shot at $^1/_{15}$ second is lighter than the rest—it is overexposed because I ran out of room to adjust the aperture and/or ISO. I kept it here because it shows the dramatic effect of my camera shake at that shutter speed.

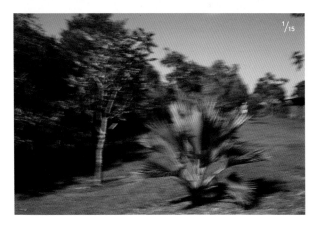

TOP—One of my pet peeves is seeing people hold their camera at arm's length to compose the image by looking at the LCD screen. The "live view" mode is needed when you shoot video with your DSLR, but your viewfinder is how you see your world when creating photographs. You have next to no control over camera shake with your arms extended. CENTER AND BOTTOM—Hold the camera up to your eye and your camera becomes an extension of your eyesight. See the world as your lens sees it! Notice that my elbows are sticking out (center). This is okay in most situations, but you want to tuck those elbows in tight to your body (bottom) if you are at the point at which you begin to see motion due to camera shake. You can also take a deep breath and hold it, then release the shutter to further stabilize your camera.

ABOVE—There will come a point when you can no longer hand hold the camera, even with the IS/VR feature turned on. *Don't* cheap out when it comes to buying a tripod! The job of a tripod is to steady the camera for long exposures *and* to protect it from falling! My heart sank on a shoot in 1996. I was in Los Angeles shooting with a model at Vasquez Rocks Park. The operative word here is *rock*. I had a Bronica medium-format camera with a brand-new 250mm lens attached to what I thought was a stable tripod. You know what is coming, so I'll make a long story short. I got lucky and lost a 35-cent homemade filter. The next day, I bought the monster tripod (above) that you see me using to this day.

created by someone whose hands tend to be steadier.

You can reduce camera shake to a degree by changing how you hold your camera. You will gain much more stability when you hold your camera to your eye to create an image.

We touched on focal lengths before. A longer lens will show the effects of camera shake faster than a shorter lens because it takes the light longer to reach the image sensor (or film) so there is more time for any dips, shifts, or shakes to become apparent in the image. A general rule of thumb is that your shutter speed limit to hand hold your camera without camera shake effects is $1/\text{focal length}$ or the closest approximation (with the IS/VR feature turned off).

MENU OPTIONS

▶ Image Stabilization/Vibration Reduction

Modern lenses have incorporated an absolutely amazing technology that somehow compensates for some of your hand motions/camera shake! Look for something like Image Stabilization (IS), Vibration Reduction (VR), or a similar term. The IS or VR feature will not have any impact on moving objects, but it can allow you to use a shutter speed one stop or more slower before showing camera shake. This option is usually accessed on the lens rather than within the camera. (Hybrid cameras tend to have this control within the camera menu options.)

▶ Disabling Image Stabilization/Vibration Reduction

Turn the IS/VR feature off if you are using a tripod and shooting at a slow shutter speed. The camera will "look" for hand motion and might actually create it if the camera is stable.

ASSIGNMENT 9

This assignment is essentially a repeat of assignment 4, but you will control the exposure changes and shoot at different focal lengths. Set your ISO to match the light in your scene. Set the camera to aperture-priority mode and take a photograph at f/11 to set the base exposure. Write down the combination of ISO, shutter speed, and f-stop. You will use this information to create the images that you want. Change the mode to manual. Set the camera to the values that you just wrote down. Take another photo with these settings (yes, the same shot you just took!).

Take a series of images of the same stationary thing at different shutter speeds. Make the necessary changes to the aperture and/or ISO to maintain a good exposure and take note of the shutter speed at which the photograph begins to look blurry. Do the same assignment with different lenses or at different focal lengths with your zoom lens. Take note of when the blur becomes noticeable at each focal length.

A faster shutter speed freezes the water coming down the waterfall, and you can see each droplet. A slow speed creates a blur as the moving water is recorded over a longer period of time. The parts of the image that are not moving record in crisp sharpness. There is no "correct" image; each has its appeal. The choice is yours.

ASSIGNMENT 10

Find a scene that has something moving—it could be a stream, waterfall, leaves blowing, kids running, anything. Stabilize your camera. Set your ISO to match the light in your scene. Put the camera on shutter-priority mode and take a photograph at $^1/_{125}$ second to set the base exposure. Write down the combination of ISO, shutter speed, and f-stop. You will use this information to create the images that you want. Change the mode to manual. What would you do if you wanted to show the motion of the moving elements while keeping the stationary objects sharp and maintain an appropriate exposure? Do it. How would you then "freeze" all of the action? Do it.[6] Photograph the moving object as it moves across your camera and again as it moves toward or away from you. What do you notice about the difference between parallel and perpendicular movement?

6. First scenario: Set a slow shutter speed and adjust either the f-stop to allow less light or lower the ISO. Second scenario: Set a fast shutter speed and adjust either the f-stop to allow more light or raise the ISO.

ASSIGNMENT 11

Put the camera on shutter-priority mode and take a photo at $^1/_{125}$ second to set the base exposure. Write down the combination of ISO, shutter speed, and f-stop. You will use this information to create the images that you want. Change the mode to manual. Find a moving target and pan with it. Try different shutter speeds to see which works best under the circumstances that you are shooting under. You'll probably be most successful in the $^1/_{30}$ to $^1/_{15}$ second range. Make the appropriate changes to maintain a good exposure. Take several shots at each shutter speed because you will miss more often than you hit the shot.

 Exposure problem: You are at an indoor sporting event and must shoot fast to stop the action. You can't use a flash. You're shooting as wide open as your camera allows, and you're still shooting too slow to stop the action. What can you do?[7]

7. Key: Increase the ISO.

The second reason for understanding how to use your shutter speed is creative control. *You* control how to show the motion in your photographs. Do you want to show the speed of the car passing your lens as a big blur, or do you want to show an athlete frozen in mid air as he or she jumps for the ball? You see a park with a waterfall and stream. Do you want the water from the falls crystal-clear in mid air, or do you want a creamy white flow of water? All of these options can help you create great photographs, and you get to choose the effect!

Here are a few more real-life examples that show the impact of your shutter speed on your image. My friend Max Brunk volunteered to break out his skateboard for this series.

There is a way to keep the moving part of your image relatively sharp while the stationary objects get blurred. It's called "panning," and it involves you moving the camera as you follow the moving objects. The moving object stays sharp because it stays in relatively the same place as you pan the camera with it. It is a tough trick to pull off, but it is a lot of fun when it works!

The shutter speed was set at $1/500$ second to freeze Max after his cut back.

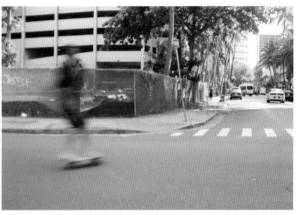

The shutter speed was set at $1/15$ second and shows almost a ghost image of Max. The camera was placed on a tripod so the rest of the scene is sharp.

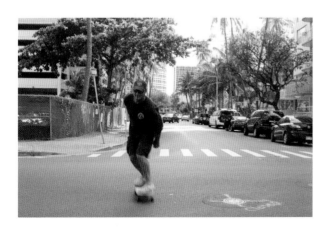

The shutter speed was set for $1/13$ second, but Max was coming toward the camera, so he stayed at the same relative position and is not blurred (note the blur of his feet: they were moving to control the skateboard).

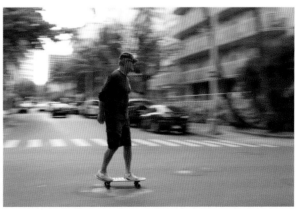

Panning with your subject can be a lot of fun and give you some unique images. It is not easy, though, so try different settings to get it right. I tried a few different shutter speeds, and $1/25$ worked the best.

5. QUANTITY OF LIGHT

▶ **All of the light rays illuminating a scene are not absorbed or reflected in equal amounts by all of the elements in the scene.**

FACING PAGE—We discussed the notion of capturing tonal values ranging from darker shadows to brighter highlights. Now we will get into the specifics of how that works and what you can do to control it. Image: Secret Island, Fiji.

Metering

Congratulations! You've made it this far and have taken a great deal of control away from your camera and put it right where it belongs—in *your* hands. However, so far the camera is still telling you what the base exposure for your image is. It is time to take control over that too. How did your camera know what the base exposure was? It used a light meter to judge the quantity of light and assigned exposure values accordingly. You can do the same thing!

All of the light rays illuminating a scene are not absorbed or reflected in equal amounts by all of the elements in the scene. This is how we see colors. The color that we see is known as the "hue." A red apple, for example, absorbs more of the green and blue light so what we see is the red light that the apple reflects. In contrast, a green apple absorbs the red light and bounces back the green. The first apple has a red hue, while the second apple

ASSIGNMENT 12

Study light! Spend a set amount of time, say an hour, and really look at and look for light sources. Take notes. Where is the light coming from, and what is it doing? Take note of how bright the light is and how harsh it is. Is there a direction to the light? Where are the shadows falling? Do the shadows fall in different directions at different times? Is there a noticeable difference in the color of the light?

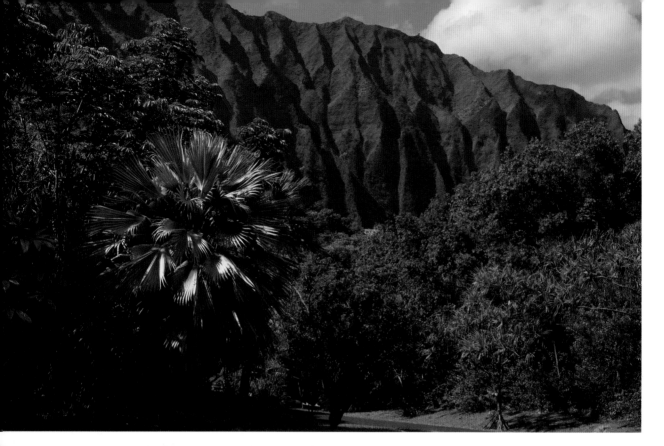

ABOVE—The highlights in the palm tree in the foreground provide some contrast in a scene that could easily become too monotone. The shadows in the mountains in the background speak to the centuries of wind, water, and selective erosion that created the spectacular façade of the majestic Ko'olau Mountain Range on O'ahu, Hawaii. LEFT—Another way to avoid a monotonous scene is to look for distinct differences in the color of the components in your image. Greens are reflected the most and dominate this image. The red reflected by the flower provides stark contrast to the greens and adds visual interest.

ASSIGNMENT 13

Take a careful look at a scene and pay close attention to the different tones and colors around you. Start to look for and notice the subtle differences in hues and tones. The human eye is so much better able to see and register the very subtle differences around us. The camera is nowhere near as good at this, and yet we will use a camera to capture an image of the scene. Begin to think about where you might lose detail and what you can do to maintain it if losing the detail would hurt the image.

My good friend Stan Cox II caught me working at my own wedding! My skin tones are close to the "neutral" rendering in the image. The camera is definitely under-exposed compared to my skin and my Barong Tagalog represents the overexposed highlights. Salamat Stan!

has a green hue. The color in our world can be vibrant and rich or flat and almost gray. The relative vibrancy of the color is known as its saturation.

How do you know for sure whether you will lose detail in either the highlights or the shadow areas? The answer lies in understanding some of the basics of exposure and how to capture a good exposure. Understanding exposure relates to accurately assessing and capturing the quantity of light in your scene. We have established that a good exposure is not a flat, one-dimensional amount of light and tones. Remember the idea that different objects reflect and absorb different amounts of light? Well a proper exposure shows as many of these different tones as possible. To review, only part of the scene recorded will reflect a "correct" exposure. Your highlights and shadows will be determined by what you decide is to be recorded as the tonal midrange of your image.

Let's back up and put this into "photo language." The exposure is based on the amount or quantity of light captured. The light captured is the amount of light that reflects off of your subject. You measure the amount of light by using a light meter. Your light meter is an amazing tool that reads the light and translates it into language that photographers understand: namely f-stop and shutter speed at a given ISO. Your meter is also a very dumb tool because it understands one thing and one thing only: Your meter will interpret the light it reads as falling right in the middle of tonal scale. This is important because whatever you meter will fall in the middle of the scale. Areas that reflect more light than your metered area will be lighter and areas that reflect less light will be darker than your metered area. This is how we create a scene that has depth and dimension, but we need to be very careful about what we meter and how we meter it.

ABOVE—Your meter will take whatever light it reads and translate it into one thing and one thing only: the middle of this gray scale. LEFT—This image of an old barn on Mauna Kea in Hawaii was captured in manual mode using the built-in reflective light meter. The meter "read" enough of the neutral tones in the scene to "place" the tones of the barn where they belong—in the shadows.

There are two kinds of light meters. All of your cameras have reflective light meters. They read the light that bounces off your subject. Reflective light meters work well in most situations. However, they need to have a range of light values coming back from your subject to give a well-rounded exposure reading. You will get a gray (midtone) image if your subject is primarily one shade (black or white). This is one reason why spot meters can be very dangerous—they read and interpret only the small center portion of the image.

Your meter is the number line that appears on your LCD screen or in your viewfinder when you are in manual mode. The middle of the number line will sometimes be marked with a zero and represents a "good" exposure. Numbers or marks on the negative side indicate that not enough light is being registered and

you need to adjust your settings to allow more light in or make the camera more sensitive to the light. Numbers or marks on the positive side indicate that too much light is being registered and you need to adjust your settings to allow less light in or make the camera less sensitive to the light.

Your job is to change any of, or any combination of, the three exposure controls (ISO, f-stop, and/or shutter speed) to get the number line to "0." Some meters will move a blinking dot along the number line and some will remove the hash marks leading to zero. Take note of where your meter reading is before you start making adjustments. You may need to make a lot of changes if you are "pinned" or "stuck" at the under or overexposed side of the meter. Keep adjusting it and you will eventually begin to see the exposure reading move.

Most scenes reflect light in varying degrees, so an average of these values will usually give you a good exposure. There are times, however, when your reflective light meter can be fooled. Dark greens, such as in trees and bushes, tend to absorb more light than you might think, so be careful with your exposure in these settings. Beautiful sunsets can be tricky to capture until you realize how your meter interprets that situation and how to compensate. Your meter will read all of the light coming at the camera and give you an accurate but bland rendition of

I set up a scene with a black portfolio and white paper to illustrate how a meter understands reflected light. I metered for the paper in the image on the left and the portfolio on the right using the spot-metering mode in the camera. Wait—is there something wrong with the meter? The overall shot metered for the paper is very dark, while the photo metered for the portfolio is way too light! Guess what? The meter worked perfectly! I pointed the spot meter at the white paper and set the camera for the reading obtained. I got a gray paper along with a very underexposed portfolio. In contrast, I wound up with a gray portfolio and overexposed paper when I pointed the meter at the black portfolio and set the camera for what the meter indicated. The meter read the reflected light off the white and black as gray. The tonal values in the corresponding photographs are all in relation to what was metered and how I metered it. I would get the exact same result in any of the program modes as well. Note that the other problem with your in-camera reflective light is its inability to read flash.

MENU OPTIONS

▶ Exposure Compensation

The number line also appears in other modes, but it has a different function. It is your exposure compensation tool in the other modes, and you want it on "0" in 99 percent of the cases. If you set the exposure compensation to a negative number, then your camera will underexpose all of the images in any of the auto modes. If it is set on a positive number, then your camera will overexpose all of the images in any of the auto modes.

ASSIGNMENT 14

Take your camera into several outdoor and indoor locations and get used to looking through your viewfinder to see and use your meter. Practice getting the number line to zero by changing each of the three exposure controls to move the marker along the meter. Remember what happens to your image when you change the f-stop, shutter speed, or shoot at a high ISO!

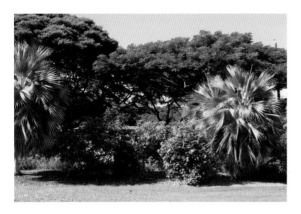

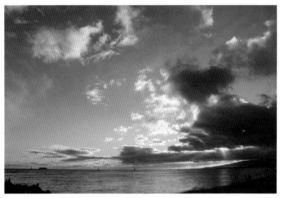

TOP—Scenes with a lot of green like this park in Honolulu, Hawaii, are tricky. Greens reflect a lot less light than you think. This image is not bad, but it is a little overexposed. The sky, for example, is a little washed out.

CENTER—Once again, this is not a "bad" image. The meter worked perfectly in this case and gave us a pleasant midtone sky. However, we do not want an accurate midtone sky for a sunset. We want deep, rich, dark colors—so we need to underexpose what the meter gave us. Image by Joan.

BOTTOM—Joan is from the Philippines and had never seen real snow. A trip to New York in December changed that. I definitely wanted to capture her first experience. The abundant snow was interpreted as gray by the meter and rendered an underexposed image.

the sky. The sky will be overexposed for what you want. Overly bright scenes, like snow, create the opposite problem.

How do we adjust the controls to give us the image that we want rather than what the meter wants? We have to go back to the concept of a stop of light. So far you have been practicing with this idea when you wanted to maintain the same exposure that the meter gave you. However, in the photos on the left, the meter worked perfectly for what it does, but it did not give us the image we wanted. For example, the meter gave us a perfectly exposed gray sheet of paper and/or black portfolio in the images on page 63. Similarly, the meter saw all of the snow and underexposed the photograph of Joan. It read a lot of dark green as gray and overexposed the image of the park. You now need to adjust those exposures to bring them back into what we want as a proper exposure. You need to increase the exposure on the white images (overexpose what the meter gave us) and decrease (underexpose) the black/darker scenes. The amount that you have to compensate will vary depending on the scene and your personal preference.

TOP—I "underexposed" the park image by ⅔ stop.
CENTER—Joan underexposed the sunset by 1⅔ stop.
BOTTOM—I "overexposed" the image of Joan in the snow by one stop. *Note:* The tonal values changed because I only adjusted one of the three controls while in the manual mode to bring the scene back into proper balance.

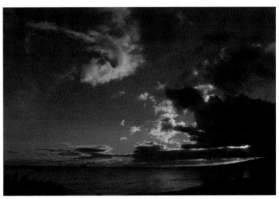

ASSIGNMENT 15

Take your camera and fill its frame with a white piece of paper. Meter the scene accurately and take a picture. What color is the image? Step back and photograph the broader scene with the paper in it, without changing the exposure. How does it look? Now find something black (paper, knapsack, purse) and fill the camera frame with it. Meter carefully and take a picture. What color is the image? Step back and photograph the broader scene with the paper in it without changing the exposure. How does it look? Do what you have to do in order to get the exposures that you want and re-photograph the scene.

ASSIGNMENT 16

Go back to assignment 13 and take a new look at the same scene. What are you going to meter to keep the most information in your highlights and your shadows? Sometimes you need to get into your scene to meter what you want to record as neutral.

MENU OPTIONS

▶ Metering Modes: Part 1

Your camera has several options that you can choose from when using the built-in light meter.

"Evaluative" (Canon) or "Matrix" (Nikon). The most commonly used mode is the "Evaluative" (Canon) or "Matrix" (Nikon) metering mode. This mode assesses and combines the light values reflecting from all of the elements in your scene and produces an average exposure that in most cases provides a good range of highlight to shadows. You will use this mode in most situations. Let's put this mode to a test. I set up a very difficult scene to photograph: a black portfolio and a white sheet of paper.

I photographed the black portfolio/white paper setup again, this time using the "evaluative" mode. This mode does a pretty good job of properly exposing a difficult scene because it reads and combines the reflected light from the black and white portions of the scene.

FACING PAGE—Joan had to literally walk into the tree to get a "proper"' neutral rendering of the intricate bark formations of this old banyan tree in Waikiki. Photo by Joan.

TOP RIGHT—Joan created this image of Waimea Park on the North Shore of O'ahu, Hawaii, using one of the auto-exposure modes with the metering mode set for evaluative. The blue sky and white clouds balance the dark greens and browns in the foreground enough to allow the meter to give a good overall exposure. Photo by Joan.

BOTTOM RIGHT—I created this image of Shark's Cove on the North Shore of O'ahu on the same day as the image that Joan made of Waimea Park. I used the evaluative metering mode to manually set the exposure for this image. The meter works the same on manual mode or any of the auto modes.

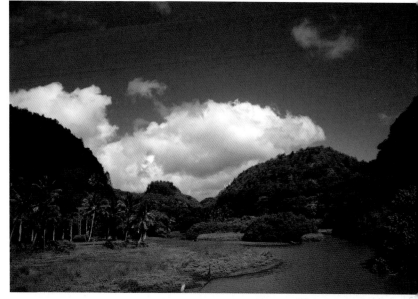

MENU OPTIONS

▶ Metering Modes: Part 2

Center-Weighted Mode. In the center-weighted metering mode, the camera takes the light information from the center portion of the scene and averages those values across the whole image. This mode can be very helpful when the object of interest is backlit. In this case, you want to center the main object to use the meter properly, then recompose to capture the image. Remember, though, that your background will be overexposed.

We begin to see some of the problems with the center-weighted metering mode here. It is taking too much information from the black portfolio and wants to make it gray. It is not too bad though because the white is still influencing the meter. Use this mode with caution only when you have to isolate the center portion of the scene. I don't think I have ever used this metering mode aside from this example.

MENU OPTIONS

▶ Metering Modes: Part 3

Spot Mode. The third common metering mode is the spot mode (Canon also has something called "partial" mode, which is essentially a broader spot). The spot mode is really a specialty tool because while it does have its place, it also highlights what your meter does—namely identify 18 percent gray. The two images on page 63 that started this discussion illustrate this point.

The effects of using a spot meter in natural environments can be quite interesting to say the least! All of the following photographs (facing page) are exposed properly according to the meter!

Why would you use a spot meter when they create such a huge range of exposures depending on where you point them? Spot meters can be very helpful in situations with a wide range of exposure values when they are used properly. You can use your spot meter to read the extreme tones and determine whether you can record enough detail in the highlights and shadows. Digital capture currently has about a five to six-stop range of functional tonal values. Use your spot meter to figure out if your scene is within that range. You'll have to make some tough choices about where to lose data (highlights versus shadows), add light to brighten the darker areas and narrow the gap, or use multiple exposures in-camera or in postproduction to create an image with a broader tonal range. I find it easier to bring back some of the shadow details than the whites in postproduction. You might have better luck if you lean toward exposing for the highlights when your scene is outside of your effective capture range.

There was a four-stop difference between the two spot-meter readings of the portfolio and paper, so I set my exposure for the middle of the two and got a decent exposure with detail in both extremes.

LEFT—The spot meter was pointed at the center of the tree on the left side of the image. CENTER—The spot meter was pointed at the reflection of trees in the water. RIGHT—The spot meter was pointed at the water.

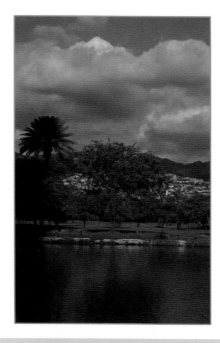 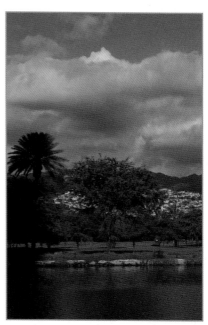

LEFT—The spot meter was pointed at the white part of the clouds. RIGHT—The spot meter was pointed at the gray part of the clouds. This is the most "accurate" of the series because the section metered was closest in reality to what the meter understands: gray.

PRO TIP

▶ Resetting the Metering Mode

Make sure that you put your metering mode back to evaluative if you use any other modes! I created the portfolio series right before my trip to the Philippines when I got engaged to Joan. I was in such a hurry to produce the lesson that I forgot to reset the camera to the evaluative mode! I spent the first few days "correcting" wildly inconsistent exposures. Thankfully, I knew enough about how meters work that I was able to override what the meter said to save the images of the most important trip of our lives up to that point. Whew! I told you that Murphy loves photography!

These were some of the images that had me scratching my head. My meter gave me wildly "accurately inaccurate" readings all week that I thankfully adjusted by shifting to manual mode to make the appropriate settings. The camera was set to spot metering mode by mistake! Left: Loboc River, Philippines. Below: Joan was the brave one who held the bees. I held the camera!

Most hand-held meters can be used as reflective meters and can read strobe lights (flash), ambient light, and the combination of these light sources. However, I prefer to use a hand-held meter as an incident meter. Incident light meters read the light that falls on your subject and place the 18 percent gray value wherever you put the meter. All darker and lighter tones fall into place naturally. You still have to be very careful about where you place the meter in your scene.

The other type of light meter is an incident light meter. These meters read the light that falls on your subject rather than the light that reflects off your scene. Your tonal values fall naturally into place because your shadows will reflect less light than what was metered and your highlights will reflect more light.

The drawback to incident light meters is you need to be close to your subject to meter the light.

ASSIGNMENT 17

Let's take a more detailed look at how your metering modes work, or don't work, for you. You will try each of your metering modes in several different situations. Photograph a scene where the sun is behind you and the light is evenly spread out in front of your camera. This is the easiest of lighting conditions. Meter the center of the scene using each metering mode on your camera. Do you notice any difference in the exposures? Which mode gave you the best overall exposure? Use that mode in these conditions. Now find a scene where the sun is in front of you and behind your subject. Meter the center of the scene using each metering mode on your camera. Do you notice any difference in the exposures? What happened to the exposure of your background? Which mode gave you the best overall exposure? Use that mode in these conditions. Finally, find a scene with a lot of contrast. Meter the center of the scene using each metering mode on your camera. Do you notice any difference in the exposures? Which mode gave you the best overall exposure? Use that mode in these conditions. Play with your spot-metering mode while you are here. Meter a darker area and photograph the scene. Now meter the bright area and photograph the scene. Is one exposure better, or are they both not so great? Which one gives you a better starting point for you to alter the exposure to maintain as much detail in the scene as you can? What happens if you shoot the scene at the midpoint of both of these exposures? For example, if your bright spot meters at f/22 and your dark area meters at f/5.6, what happens if you shoot the scene at f/11 (keeping your shutter speed and ISO the same)? Use your spot meter in tricky situations to see if the range of exposures falls within six stops and to help you decide the best overall exposure.

We mentioned that the reflective light meter in your camera couldn't read a strobe or flash. This is a major problem when you need to accurately measure the light coming from the flash—and especially when you are blending the flash with ambient light. A good hand-held incident light meter will provide the data for the ambient light, the strobe, and the combination of all of your lights. This image of Tasha Johnson was part of a series in one of the boat harbors in Honolulu. We added a silver/gold reflector to the beauty dish that you have seen before.

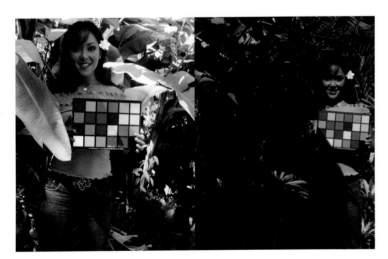
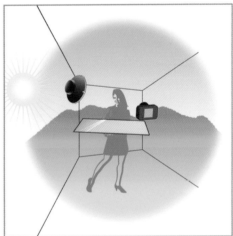

Both of these images of Kat are exposed properly. In this case, we used an incident light meter positioned at the color card both times. The card is properly exposed in both photographs, but one image looks darker than the other because of the relationship of the surrounding areas to the color card. There is less light in the bushes than in the direct sunlight. The leaves appear darker (in shadow) when we metered for the card in the sunlight. However, they appear much lighter when Kat moved the color card into the shade. There was less light in the shade, so we had to allow more light into the camera (choosing a smaller-number f-stop to open the aperture more, slower shutter speed, and/or a higher ISO). We allowed more of the light in the shade to be recorded so the leaves look lighter. The important thing to remember about this is that *we* decided what the important part of the image was and metered/exposed for *that* area. So can/will you!
Note: Turn the color card upside down if you want to use the gray scale strip for color-correction purposes.

ASSIGNMENT 18

Set your camera to manual mode. Locate three different scenes: one "high key" or bright, one "low key" or dark, and one with mixed contrast. Use your meter to determine the "proper" exposure. Shoot several shots at this exposure, then get creative. Remember that your meter is stupid. It thinks that the tone in your image is 18 percent gray. Think in f-stops. Do you want your "high key" to be middle gray, or closer to white with detail? Do you want your moody, dark scene to be muddy gray, or closer to black with detail? Find a scene (contrasty) in which the range is outside the sensor's latitude. What now? It is time to decide what the important portions of the image are! Meter and shoot for the highlights, then again for the shadows. Examine the scene and decide what you want to be middle gray, meter that—note and set the proper f-stop and shutter speed, back up and shoot. Remember the assignment for which you purposefully under and overexposed your images? Here's where that exercise will come in handy: You have just used your reflective in-camera meter and photographed a high-key (bright) scene, but the highlights appear too gray. Why did this happen and how would you fix it (would you allow more or less light into your camera)? What about a darker scene? Make some adjustments, take note of the new exposures, and compare your results.

ASSIGNMENT 19

Let's have a little fun before we continue with the technical aspects of light. In assignment 12, you studied the light around you and took note of the many different light sources. You will be using those various light sources to illuminate your scenes, but for now your job is to create at least five different images in which the main subject of the photograph is the light. Examples of this might be neon signs, long exposures of car headlights at night, sunsets, or the sun streaking through the clouds onto the ocean. Get creative! This assignment will really help you to look at light in different ways.

Light was used to create these images of the Fourth of July fireworks in Waikiki, Hawaii, and Star City in Manila, but it also became the main subject. The best fireworks settings were 5 seconds at f/13.

6. COLOR CONCERNS

It is important to understand the impact that your color controls have on your images. Start to think about color *before* you create your photograph. Your digital camera will create a file of many millions of different shades of colors. One of the first things to consider is the color space that you will work within.

The iconic view of Waikiki and Diamond Head on O'ahu and the beautiful West Coast of Mau'i were photographed at sunset. The warm amber color of the images was a result of the color temperature of the light during that time of day.

Color Space

Imagine that you have several boxes filled with colors. You have different-sized boxes holding different amounts of colors. That is the easiest way that I can think of to explain color spaces. You create and work with images in these boxes. The three most common color spaces are sRGB, Adobe RGB (1998), and ProColor. ProColor is the largest "box" and has limited use as of this writing. Adobe RGB (1998) is the next largest and is currently much more useful. sRGB is the smallest box and is the most commonly used color space. Most digital cameras can be set for either sRGB or Adobe RGB (1998). The preset does not matter if you shoot RAW because you can choose the color space that you want to edit in when you import the images into Photoshop, if you use that program. Color space is important when you think about what you will do with your photos. Many commercial print labs use a color profile based on Adobe RGB (1998). Your colors might look muted if you give them an sRGB file. Conversely, most computer/television/phone/tablet screens are set up for sRGB color. I always do my initial edits

in Adobe RGB (1998) and then "downsize" to sRGB for computer/LCD screen purposes.

You started your studies with your white balance setting on auto. Most of your images probably look fine, but some may have a subtle—or not so subtle—color shift where the colors in your images don't quite look right. The shift is probably due to a mismatch in the kind of light that your camera expected, the light that was recorded, and the auto feature's inability to correct it. Different lights actually have different temperatures that yield different colors. The term for this is "color temperature."

Color Temperature

There are many different light sources, and each has a different color. At some point in history, someone had way too much free time and sat and watched a black-body radiator heat up. The color changed as the stove got hotter, and the notion of "color temperature" was born. Color temperature refers to the temperature of the radiator that corresponds to the color emitted by it as it heats up. Each color was assigned a temperature on the Kelvin scale. "White" light measured about 5,500 degrees Kelvin. Colors that were emitted at lower temperatures (e.g., 3,200 degrees) were generally along the orange/red spectrum. Higher temperatures would yield colors along the blue/green spectrum. Color temperature, in photography, refers to the color of the light source. Our eyes interpret most light as white. Our cameras are not as good at adjusting to the different colors in our world. You will get unwanted color shifts if your capture media (film or digital) is not in sync with the color temperature of your light source.

There are several things that affect the color temperature of the light that are of importance to you at this point in your photographic endeavors. We just mentioned that various types of light (e.g., incandescent, daylight, fluorescent) have different color temperatures. However, even sunlight has different color temperatures depending on the time of day, weather conditions, and where you are. High noon on a sunny day is about 5,500 degrees Kelvin. Sunrise and sunset light is much cooler—closer to tungsten at 3,200 degrees Kelvin. You'll get an amber cast to your photos at sunset if your camera is looking for high noon light or light from a strobe (most strobes, or flashes, are closely matched to high-noon sunlight). However, a cloudy day will have a higher color temperature as will open shade or a spot high in the mountains. Your photos will look blue if your camera is looking for high-noon sun and you shoot in open shade.

The color temperature of your light source can be affected by the way you choose to modify your light. Light can be transmitted through semi-opaque materials. We often use this technique to "soften" direct sunlight (see "Quality of Light" on page 103). We can also use reflective materials to bounce light around. White materials will lower the color temperature of the light, while silver reflectors will raise the color temperature.

White Balance

We used to buy different films that were "balanced" for the color temperature of the lights used. Tungsten films were used with lights of a lower color temperature, and "daylight" film was used for lights with higher mid-range color temperatures. We would also use color temperature gels to adjust the color of the lights to match our film. Now we use the

MENU OPTIONS

▶ White Balance Controls

Your camera has a menu subfolder for white balance controls. Some cameras have a "WB" button on the body of the camera that quickly accesses these controls. I find it easier to go through the menus on other cameras. You will find several presets for different light sources such as tungsten/incandescent, daylight, flash, fluorescent, shade, clouds, and custom (or "preset manual").

Approximate Color Temperature	Lighting Situation
Tungsten	3200 Degrees Kelvin
Sunrise/Sunset	3200 to 4000 degrees Kelvin
White Fluorescent	4000 degrees Kelvin
High Noon Daylight	5500 degrees Kelvin
Flash	5500 degrees Kelvin
Clouds	6000 degrees Kelvin
Shade	7000 degrees Kelvin'
Mountains or Forest	Up to 10,000 degrees Kelvin

Color Temperature Range	WB Set on the Camera	Color Shift
Lower	Lower	Neutral
Higher	Higher	Neutral
Lower	Higher	Orange
Higher	Lower	Blue

white balance controls on our digital camera to match what the camera is looking for to the light source. Most digital cameras have several presets that will work nicely in most situations. Simply change the preset to match where you are shooting and you are good to go. There is an "auto" white balance preset too, but I am not a fan of anything auto. In all seriousness, the auto white balance setting does not work as reliably as I would like. You can also set a "custom" white balance on most digital cameras that will neutralize any color shift in what illuminates your subject.

Your camera understands color temperature in terms of white balance settings. Match the preset or do a careful custom white balance (check your manual to see if your camera has this feature and how to use it) and your photos will have natural-looking colors.

The lower chart on page 76 shows what you can expect from different color temperature white balance match-ups.

The following images of Kapiolani Botanical Gardens were created during the middle of the day with the camera on different white balance presets.

The tungsten/incandescent preset looks for light in the 3,200 degree range. The color temperature of the daylight was higher, so the result is a blue color cast.

The fluorescent preset looks for light in the 4,000 degree range. The color temperature of the daylight was higher, so the result is a blue color cast.

The flash preset looks for light in the 5,000–5,500 degree range. The color temperature of the daylight was within this range, so the result is a neutral color.

The daylight preset looks for light in the 5,000–5,500 degree range. The color temperature of the daylight was within this range, so the result is a neutral color.

The cloudy preset looks for light in the 6,000 degree range. The color temperature of the daylight was lower, so the result is a slight amber color cast.

The shade preset looks for light in the 7,000 degree range. The color temperature of the daylight was lower, so the result is an amber color cast.

Some cameras allow you to select specific Kelvin temperatures
to use as your white balance. The specific color temperatures
work the same way as the presets:

The 3,000 degree preset
looks for light with a low
color temperature. The
color temperature of the
daylight was higher, so the
result is a blue color cast.

The 4,000 degree preset
looks for light with a low
color temperature. The
color temperature of the
daylight was higher, so the
result is a blue color cast.

The 5,000 degree
preset looks for light
with a midrange color
temperature. The color
temperature of the daylight
was within this range, so the
result is a neutral color cast.

The 6,000 degree preset
looks for light with a
slightly higher color
temperature. The color
temperature of the daylight
was lower, so the result is a
slight amber color cast.

The 7,000 degree preset
looks for light with a higher
color temperature. The
color temperature of the
daylight was lower, so the
result is an amber color
cast.

The 8,000 degree preset
looks for light with a higher
color temperature. The
color temperature of the
daylight was lower, so the
result is an amber color
cast.

The 9,000 degree preset
looks for light with a higher
color temperature. The
color temperature of the
daylight was lower, so the
result is an amber color
cast.

The 10,000 degree preset
looks for light with a higher
color temperature. The
color temperature of the
daylight was lower, so the
result is an amber color
cast.

FACING PAGE—I manually set my white balance to about 4,500 degrees Kelvin to create this image of Thalia Ng. The
manual white balance setting kept some of the amber tone of a lower color temperature without too severe of a
color cast.

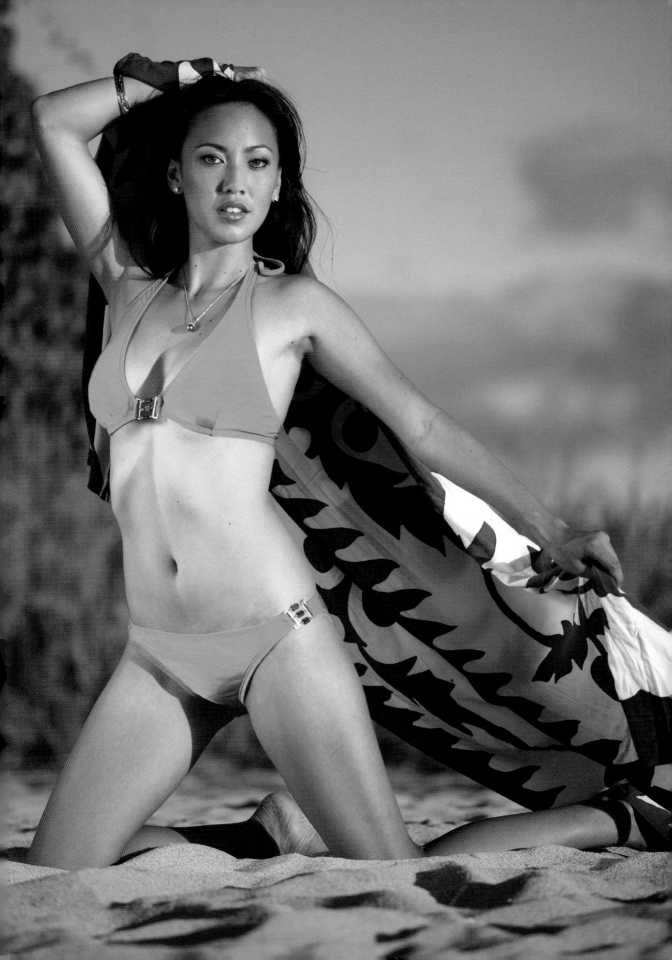

I like this feature because I can fine-tune how I want to render my colors. For example, I like the warm look of a photo shot on a beach at sunset. This is actually a tough situation because my image will be too orange/amber if I set my white balance on daylight. However, I will neutralize all of those warm tones if I select the tungsten white balance preset. I can dial in a median color temperature if my camera allows this much control and achieve a nice compromise (see page 79).

Most cameras allow you to create a custom white balance. A custom white balance will read the scene in which you are shooting and completely neutralize the color of the light. I rarely use this feature, but it can be very effective when you are in situations where different light sources are overlapping and none of your presets are accurate. The owner's manual that came with your camera will tell you how to do this, but you want to photograph something all white or all gray to give your camera the data it needs. I don't recommend using white paper because there is too much blue in the material. There are many tools on the market that you can use to set your custom white balance. I use an old white t-shirt, and

it works fine. I know that there are many professionals who would disagree strongly with what I just said, and they are correct: white shirts also have a lot of blue in them. The custom white balance will compensate for the blue and add some yellow to the image. I have been using an old (washed many times) white shirt for years, and I like my results. I do, however, prefer my images to be slightly on the warm side. It is important to note that a custom white balance will not solve all of the color problems. A custom white balance will neutralize the color of the light that falls on your subject. However, you can still get very bad color shifts in the background if that is lit by different light sources. Remember to either set a new custom white balance or change the preset when you move to and/or change the lighting situation.

Color Balance

"Color balance" is a different color issue. Remember that light sources emit light along the red, green, and blue channels. Most light sources emit essentially equal amounts of light along each spectrum. Some lights, like old fluorescents and mercury-vapor bulbs,

ASSIGNMENT 20

Find an indoor setting, an outdoor setting at high noon on a sunny day, an outdoor setting at sunrise or sunset, an outdoor setting in open shade, and an outdoor setting on a cloudy day. Shoot one image of the same thing at each of your camera's white balance presets. Create a custom white balance (see your camera's manual for instructions) in each setting. Play with setting your own color temperature if your camera allows it. Take note of which preset or other setting gives you the most pleasing result in each setting. Go back to the indoor setting and run through the series again using a flash. Note the differences between flash and no flash.

emit different amounts of light along the three channels. Old fluorescents, for example, emit more green light than red or blue light. Color balance issues need to be fixed; otherwise, you will get unpleasant color shifts in your photographs. A custom white balance will neutralize the problem if the light source is consistent across your entire scene.

Use a flash whenever possible when photographing creatures (or people!) underwater to maintain neutral colors. The available light underwater is an example of light that appears to be out of balance. Technically the source of the light is the sun, so it is in balance, but the water defracts and eliminates the shorter red and orange light waves. The recorded light is primarily made up of the green and blue wavelengths. You can use a flash to bring the recorded light back into balance. Photos by Max Brunk, Manini Dive Company, Hawaii.

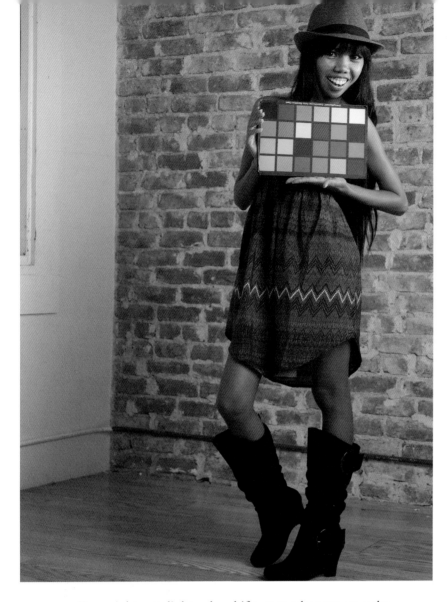

You can use a color checker for your reference points and use a program like Adobe Lightroom or Photoshop to adjust the whites, midtones, and blacks to neutralize any remaining color shifts in your photograph.

You might get slight color shifts even when you use the correct white balance preset; that is the nature of digital photography. I always use a color checker when I shoot anything serious.

Color Checkers

Many digital files need some degree of color correction in postproduction, even when the white balance is correct. Color checkers, also known as color cards, are used in postproduction to neutralize any color shifts in the whites, blacks, and midtones of your image. Color checkers can come with swatches in gray scale and/or with a variety of colors.

▶ **You might get slight color shifts even when you use the correct white balance preset; that is the nature of digital photography.**

7. LENSES

Focal Lengths Revisited

Focal length is the distance that light travels from the outer element of your lens to the sensor. Focal length determines your field of view and the magnification of the elements in your photograph. Focal length has no impact on depth of field. The impact of focal length on perspective depends on how you define perspective.

"Normal" lenses provide a field of view similar to what the human eye sees.

"Wide-angle" lenses provide a field of view that is wider than what the human eye sees. The elements in the scene are smaller.

"Telephoto" lenses provide a narrower field of view than what the human eye sees. The elements in the scene are larger.

Here is how that works: Your camera's job is to fill the area of your sensor with data. Your focal length will be considered normal, wide, or telephoto depending on the length of the lens and the size of your film or sensor. The normal

TERMS

▶ Field of View
Field of view is the amount of the scene that your lens is able to "see" and record.

▶ Magnification
Magnification refers to how large the elements in your scene look when photographed.

The type of sensor that you have will impact the optical focal length of your lenses. Full frame sensors on DSLRs tend to be 1.5 or 1.6X bigger than cropped frame sensors. The effective focal length of your lenses are different as a result. The image on the left was shot with a 50mm lens on a full-frame sensor camera. The image on the right was shot from the exact same location with a 50mm lens on a cropped frame sensor. The effective focal length of the lens on the camera with the cropped frame sensor is 1.6X the length of the lens on the full frame camera. *Note:* The crop ratio is different on many of the smaller "hybrid" cameras.

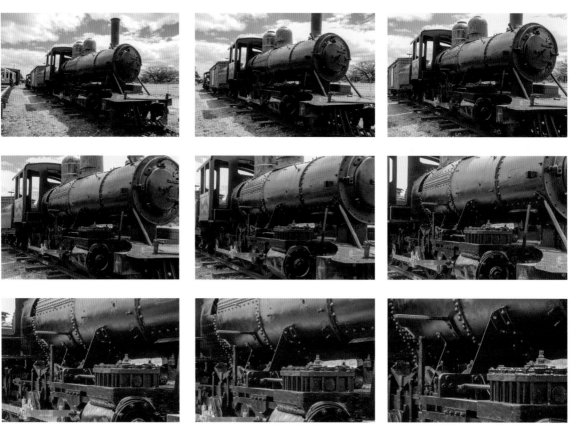

I photographed this old train at several focal lengths on a zoom lens. The field of view gets narrower and the photographed elements get larger as we go from a wider focal length to a longer focal length.

lenses fill that area with a scene that is similar to what we see with our eyes. Wide-angle lenses force more of the scene into this area, so the elements that make up the photograph need to be smaller. In contrast, telephoto lenses show a narrower field of view and need to magnify the elements in order to fill the sensor.

The specific focal length that is considered normal, wide, or telephoto varies depending on the size of the film/sensor. The focal length of normal lenses is approximately equal to the diagonal line created by splitting the square/rectangle film/sensor. Lenses with a focal length that is shorter than that diagonal line are considered to be wide angle. Lenses with a focal length that is longer than that diagonal line

are considered to be telephoto. For example, a piece of 35mm film measures about 24x36mm. A normal lens for this size film is about 50mm. That same focal length would be a slightly wide-angle lens for a medium format (6x6cm or 60mm) piece of film. The normal lens for this camera would be about 85mm. An 8x10 camera takes a 325mm lens to provide a normal angle of view.

This explains the two images that started this discussion (page 83). The area of the full-frame sensor approximates a piece of 35mm film, so a 50mm lens is a normal lens with that sensor. It becomes a longer lens on a cropped-frame sensor because the capture medium is smaller.

"Zoom" lenses are comprised of many focal lengths in one shell. You are able to change the

ASSIGNMENT 21

Pick three focal lengths (wide, normal, and telephoto). Use either three prime lenses or choose three spots on your zoom. Spend one hour shooting images at each focal length—no cheating! Get used to how your camera "sees" the world at each focal length!

ASSIGNMENT 22

Find a friend and stand about 6 feet away from them. Take a photograph with them turned toward the camera with a wide, normal, and telephoto focal length. Make a note of the differences. You'll likely prefer the images shot with the two telephoto focal lengths because they tend to be the most flattering for faces—although too long of a lens can compress the facial features too much.

focal length and, therefore, the field of view and magnification of your elements simply by extending or retracting the barrel of the lens.

"Prime" lenses are fixed focal length lenses. You cannot change the focal length on these lenses.

There are pros and cons to prime lenses as well as zoom lenses. Prime lenses are often "faster" than zoom lenses, meaning that they have a larger maximum lens opening (f-stop) than zoom lenses. Many zoom lenses have variable maximum f-stops, meaning that the largest f-stop available changes as the focal length changes. However, it is much easier and faster to change focal lengths with a zoom lens than it is to change prime lenses, and all of the intermediate focal lengths (the ones between prime lenses) are available. There was a time when prime lenses were considerably sharper than zoom lenses, but times have changed and most zoom lenses will give you a tack-sharp image. There is a great debate over the artistic merits of each lens system. I've used both and, at this time, I like the creative flexibility that zoom lenses offer.

Super-wide-angle lenses are expensive, so be careful about buying them for cropped-frame cameras. Some manufacturers make lenses specifically for cropped-frame cameras. Some of these can be used on full-frame cameras, but they do not always work well. Some give you darkened corners at the "longer" lengths when used on a full-frame camera. You might also see a "bowing" or bending of your straight lines at the edges with a super-wide-angle lens. The angle of view is so great that the lines of light bend at the edges as they are forced into the lens.

Lens/Focal Length Myths

There are a couple of common, and incorrect, notions about the impact your focal length has on your image.

Myth #1. We have already debunked the idea that "Wide angle lenses increase your depth of field, while telephoto lenses create a shallow range of focus." We stated earlier that the two factors that influence depth of field are your f-stop and the physical distance to your subject. Focal length has nothing to do with depth of field.

Myth #2. "Changing your focal length changes the perspective of the image." I suppose that this depends on your definition of "perspective." Some people define perspective

LEFT—Here is a photograph of Christine Pham with the lens set at about 44mm. The angle of view is such that the beach, water, and slippers become part of the composition and scene.
CENTER—We did not move the camera for this closer image—we simply changed the focal length (in this case, to 135mm). The angle of view is more restricted, and the portion of Christine that is visible has been magnified.
RIGHT—The image of Christine from a distance may appear to have a greater depth of field because the elements in the photo are smaller and it is harder to see the focus transitions. However, we see that the actual depth of field is identical when we magnify the center of the distant image to match the proportions of the photograph captured at the telephoto setting.

as it relates to how close or far away the elements in your photographs appear to each other. We've established the fact that you will see more elements in your image (field of view) and those elements will be smaller (less magnification) when using a wide-angle lens. This will create the illusion that those elements are farther away from each other. Conversely, you will see fewer elements at a greater magnification with a telephoto lens, creating the appearance that the objects are closer than they really are (i.e., the scene will appear compressed). Changing your focal length will change the perspective, if this is the definition you choose.

Perspective, for me, refers to the relationship between the relative size of the elements in your photograph in relation to each other. Changing your focal length will modify the size of all of your elements but will not change the relative size between them.

Moving your camera will change the perspective between the elements in your image. Objects that are closer to your lens appear larger than those farther away, regardless of your focal length. You can use this fact to create some fun images.

PRO TIP

▶ Avoid Distortion

Keep your subject centered if you have to use a wide-angle lens to photograph people, especially when you are closer to them. The center of your lens is "truer" than the edges and will not bow any lines at the wider angles.

Here is the beach front as seen from the restaurant at the Club Fiji Resort in Nadi, Fiji. The image was taken with the lens set at 18mm. Note the relative size of the elements in the image.

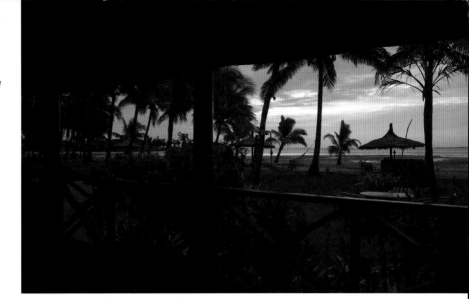

Here is the same scene photographed with the lens set at 65mm. The center portion is larger, but the relationship between the elements is the same.

Here we see a cropped version of the wide-angle shot where the center portion has been magnified to approximate the angle of view captured at 65mm. There is no difference in the relative size between the elements: the perspective is identical.

A critical step in creating pleasing photographs of people is recognizing the fact that objects that are closer to the lens appear larger. You want to avoid posing people with any joints (elbows, knees, shoulders, fingers) positioned where they are aimed right at the camera, especially if you are close to your subject. The joint aimed at the lens will look much larger than you realize and create a very unflattering image.

BELOW—The size of the plant is exaggerated compared to the rest of the scene. I was playing with a 27mm lens that day and moved the camera closer to the plant to make it look larger.
FACING PAGE—One technique that is often used in advertising photography is to bring the camera closer to the primary part of the scene. The change in perspective emphasizes the part you want to highlight. In this case, I moved in close to Kristen's shoes to simulate what could be a shoe advertisement. The shoes appear larger than life because of the proximity of the camera.

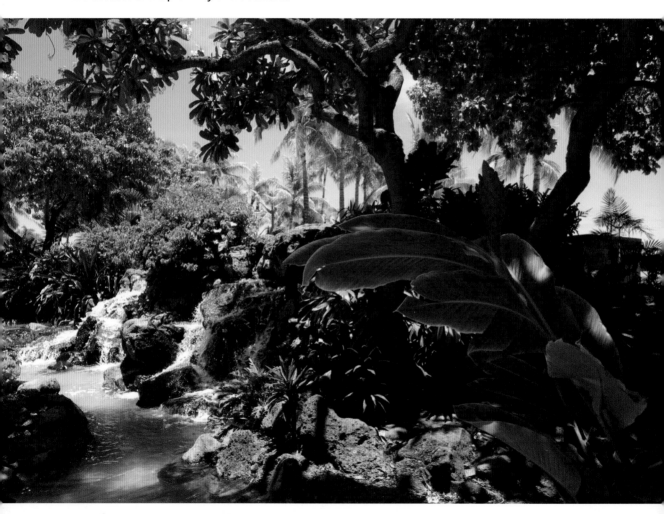

ASSIGNMENT 23

Play with the idea that moving your camera closer to something will make it appear larger. Go out and make small things look huge. Try to include something that is actually larger in the background as a point of reference.

Be aware of "keystoning." Keystoning occurs when you tilt your camera up or down to take the photo. This is often seen when people photograph tall buildings. The bottom of the building is closer to the lens than the top and appears larger. The

FACING PAGE AND ABOVE—This image of Tasha Johnson was created by carefully positioning her body. Her shoulder is turned to the camera and her hand is closer to the camera as well, but the body parts still look natural and pleasing. The image was made using just window light on Tasha's face. A large white card was used as a reflector. We will discuss reflected light later.

ABOVE AND RIGHT—Make sure that body joints are pointed away from the camera whenever an arm or leg is bent! Model: Sharon Sanchez. The shade of the building (indicated by the "scrim" in the diagram) provided a soft quality of light, while a strobe in a beauty dish created the needed contrast and directionality to the light. We will discuss quality of light issues shortly.

top of the building looks narrower, and the lines of the building converge together.

You absolutely do not want to do this when photographing people! Shooting up at them will give them big feet, and shooting down on them will give them a big head. Neither option is good!

ABOVE—Keystoning is hard to avoid when photographing tall buildings like these in Times Square in New York City.
LEFT—On the other hand, you can use this effect to create an overpowering or omnipotent feeling with your image. Joan's photograph of the statue of Santa Rita in St. Augustine Church in Manila is a perfect use of keystoning.

ASSIGNMENT 24

This was one of my favorite assignments when I was learning photography. I still remember it more than thirty-five years later! Find one subject and photograph it from thirty-six different angles! Be creative and use caution when metering.

ABOVE—You can lower your camera when photographing people, but make sure that the lens is parallel to your subject. My camera is always set lower to the ground when I photograph models because it provides the appearance of greater height. However, I do not tilt the camera up to compensate for the low angle. Model: Joan. I don't remember the specific lighting scheme for this image.

RIGHT—I shoot from a lower perspective even when creating formal portraits or headshots like this image of Shelby. However, the camera is always parallel to the person and never tilted.

Take your camera and look at the world from different angles. Bring your camera low to the ground or aim it straight up to the sky. There are so many ways to capture different perspectives. Go have some fun before the "lectures" begin again!

▶ There are so many ways to capture different perspectives. Go have some fun before the "lectures" begin again!

8. A CLOSER LOOK AT LIGHT

In the first part of this book, you learned how to use your camera to effectively and creatively record light. It is time now to take a closer look at some of the properties of light that will make you an even better photographer. Light works in many predictable, yet at times confusing, ways. We have already talked a lot about two of these properties, namely that light is absorbed and reflected by the various things in our world. But, where does light come from? Light can be direct or indirect and can come from many sources. One of the first things to consider when looking at light is its direction: where is it coming from? You may have one or

Understanding light is the key to creating great photographs. The light quality and direction are very different in these two photographs taken in Boracay, Philippines. The path to the beach at the Nigi Nigi Too Resort is backlit, and the bright highlights on the palm trees belie a fairly harsh quality of light. In contrast, the light in the restaurant on one of the many islands in the area is predominantly soft, and diffused light is coming in from the windows to the right. However, the shadow of the table indicates a more direct light source from camera left.

more lights illuminating your scene. The light that provides the main basis for your exposure will also usually determine where and how the shadows fall. This is generally known as your main or key light. Fill lights are other sources of illumination used to soften shadows or brighten the darker parts of what you are photographing. You started to critically examine your scenes in assignment 13 when you began to see the range of highlights to shadows in front of you. You might choose to use a second light source to "fill in" some of those darker areas and keep some of the detail you might have lost otherwise. You can do this by bouncing or reflecting light off of any number of surfaces to create an indirect source of light.

Reflected Light

You are not lost if you find yourself in situations where the scene has a lot of contrast or areas in your scene are too dark for what you want. We've talked about the reflective property of light as it relates to exposure, but you can also take something that reflects a lot of light and "bounce" light from a light source into darker or shadow areas of your scene. Parabolic reflectors (right) will allow many light rays to travel undisturbed while it "catches" and redirects other rays to follow the same general path. (You may see these referred to as "lamp reflectors.")

The silver cylinder that is attached to my strobe is called a "parabolic" reflector. Parabolic reflectors focus and channel the emitted light rays along a parallel axis and are usually used to focus the light from a strobe or flash. We will see an example of this in use later.

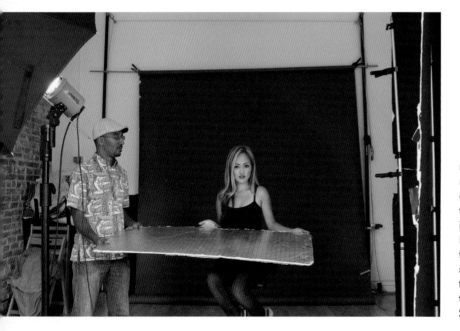

LEFT AND FACING PAGE—Plane reflectors are much more common and tend to be flatter objects that are used to redirect light into darker areas of the image. Reflectors need not be rigid; in fact, some of the best ones have some pliability to allow you to fine-tune where you want the light to go. Thanks, Christopher and Sharon!

It will look like you are "adding" light to the dark areas, but all you are really doing is moving existing light to fill the shadows or add highlights to your scene.

There are a few things that you have to think about when using reflected light. There are many types of reflectors that you

The image on the left was shot straight. I had to adjust the exposure a bit because the meter read too much green and overexposed the photograph. The tones across this image are acceptable, but the lower-right corner is a little dark. We "bounced" some of the direct sunlight into the corner using a silver reflector. The result is subtle, but there is more detail.

ASSIGNMENT 25

Spend some time looking around your home or your neighborhood and take note of the many things that you can use to bounce light around. It could be a wall or a ceiling or a much smaller object. Write them down and also note the properties of the things that reflect light. Is the reflector smooth or textured? Large or small? What color is it? You will photograph scenes with each of these characteristics in a while to compare them, but for now, just compile your list.

Water can be an amazing reflector that will give you very different results whether the water is still or has some current flowing. Photo by Joan.

▶ **Put simply, light bounces off reflective surfaces at the exact angle that it hits the surface.**

ASSIGNMENT 26

Get a flashlight and a mirror. Shine the flashlight into the mirror at different angles. See where the reflected light goes. The angle that the light hits the mirror is the exact angle that it reflects off of the mirror. You will practice this in the field next.

can buy—and I have several commercial products that I use, but if you think about it you can use almost anything to bounce light.

One of the important laws of light that is emphasized by the use of reflectors is "The angle of incidence equals the angle of reflectance." Put simply, light bounces off reflective surfaces at the exact angle that it hits the surface. This law is particularly apparent when you are working with smooth reflectors. It is also why we get "red eye" when using an on-camera flash: the flash

sends out a blast of light that hits our highly reflective retina and bounces back at the exact same angle to burn a red spot in the image.

Textured reflectors have more than one surface, so the light is reflected in many different directions. The general direction of the reflected light will still follow the angle of incidence law on a broad scale, but the individual light rays that make up the stream of light will be more scattered or dispersed. The reflected light will tend to be more diffuse and less sharp than light bounced off of a smooth surface. Textured reflectors include fabrics, crumpled paper, form boards, walls, ceilings, etc.

ASSIGNMENT 27

Find an area with direct sunlight and open shade. Practice bouncing light from the sunlit area into the shady area. Use a smooth, shiny reflector to clearly see where the light goes as you change the angle of the reflector. Choose an area of the shade and practice aiming the reflection at that spot. Change to a textured reflector and notice the difference in how the reflected light looks.

FACING PAGE AND BOTTOM LEFT—The white fabric reflector is a textured material that bounces back scattered, diffused light that still follows the general rule of the angle of incidence law. The reflector is positioned relative to where the light source is, where you want to fill the shadows and, of course, the camera axis.
BOTTOM RIGHT—A smooth Plexiglas mirror was used here to add direct and sharp highlights to Rayna's hair. Pete May positioned the reflectors shown in this series as other students photographed Rayna.

ASSIGNMENT 28

Find an area with direct sunlight and open shade. Practice bouncing light from the sunlit area into the shady area. Use a small reflector and note how the light looks. Change to a larger reflector and notice the difference in how the reflected light looks.

ASSIGNMENT 29

Find a neutral color background like a gray wall and find different-colored reflective surfaces to bounce light onto the backdrop. Note what happens to the color of the background as a result of the reflected light.

ASSIGNMENT 30

Get a flashlight and stand in a dark room with a mirror. Turn the flashlight on and shine it onto your face. Move the flashlight around and notice how the shadow from your nose changes as the position of your light changes.

FACING PAGE—Be aware that the color of the reflector chosen will bounce into the scene along with the reflected light. I chose a silver/gold reflector to create this late-afternoon fashion image of Naomye Leiza to accent the look of the time of day.

Shiny, smooth reflectors will give you a sharply defined area of light that is better used for adding hotspots and contrast than as a general source of light to fill any shadow areas on your subject. Examples of smooth, sharp reflectors are mirrors or boards covered in smooth aluminum foil.

The size of your reflector will influence how the bounced light works and looks. Smaller reflectors will have a more direct and harsh bounce than larger ones.

The light will take on the color of the surface that the light is reflected from. The color of the reflector will be bounced into your scene in addition to the light, so be very aware of what surfaces might be bouncing light around your set. Avoid things that will create nasty color casts, like a green wall. White walls or ceilings can produce a very pleasing, neutral light to work with.

Quality of Light

Have you noticed that some of your images have deep, dark shadows and some hardly have any shadows at all? Shadows are formed when the path of light is blocked by something. Shadows create the three-dimensional feel within a two-dimensional medium and define the direction of the light emanating from your light source. Portrait styles, for example, are

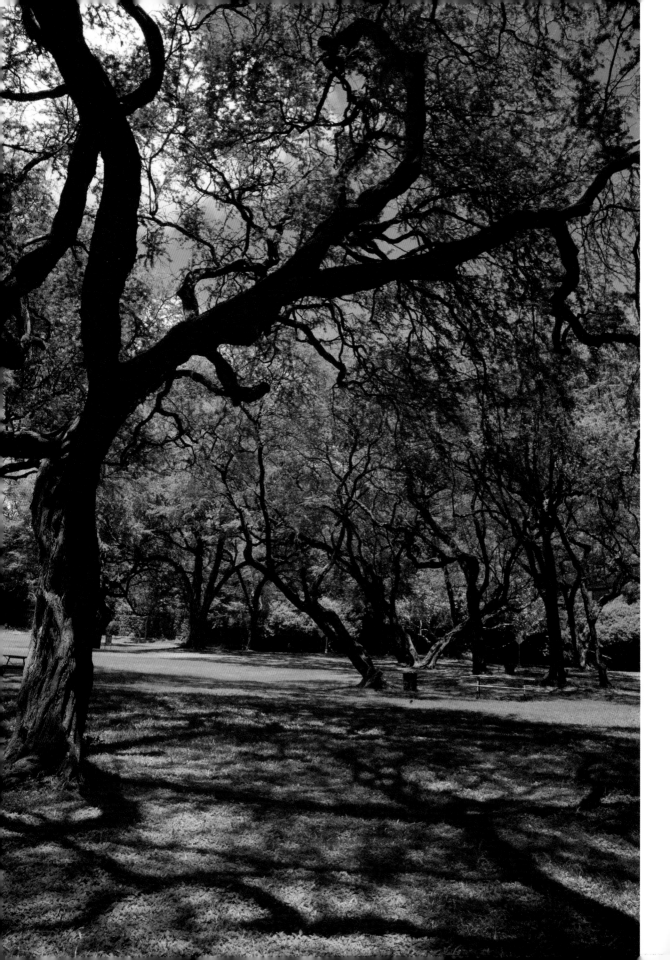

ASSIGNMENT 31

Find a stationary object that has a lot of texture. An old barn and a tree trunk are some examples. Spend a day where you can photograph this thing from different angles every hour or two from sunrise to sunset. Compare the photographs and make note of the differences.

defined by shadow patterns created by the nose, depending on where the subject is in relation to the light.

Shadows and the Time of Day

Shadows in nature work in much the same way as the sun changes its position in the sky over the course of a day. The angle of the sun casts distinctly different shadow patterns at different times of the day, each with different pros and cons. The position of the sun in the morning and afternoon hours is much lower along the horizon of the Earth. The shadows created stream across your subject, and the light will accent the texture of what you are photographing. The sunlight is more likely to be broken up by atmospheric elements during these hours, so the shadows, while longer than at midday, tend not to be as dark. Midday sun casts shorter but deeper shadows. The light does not show the texture of your subject as much but is spread more evenly across your scene. This may be an advantage if you need to show detail across the entire shot. Remember, though, that you may lose more detail in the areas where the shadows do fall.

The depth, intensity, and tone of your shadows are dependent upon the quality of light in your images. A harsh quality of light is defined by a quick and abrupt transition from highlight to shadow coupled with deep, dark shadows. Soft light, in contrast, produces

a smooth, gradual transition from highlights to shadows, and those shadows are light and muted.

The sun is the most obvious and familiar source of light. Sunlight, like any light source, can be direct, as in a cloudless sky. Direct sunlight tends to produce deep, dark shadows like those shown in the image on the facing page. However, it can produce a much softer source of illumination when it is diffused by a cloud cover or fabric. Clouds are actually made of many droplets of water that light travels through. The water acts like any other translucent material and bends the light waves in many different directions. In other words, the water acts as a mass diffuser. However, light that is diffused through clouds may appear to lack direction and result in a flat, lifeless photograph.

Indirect sunlight, like open shade or window light, will produce a softer light quality. This light, while sharing some of the characteristics of cloudy skies, often has more direction to it. The light will fade the deeper you go into the shade.

There are two factors that determine your quality of light: the size of your light source and the distance between your light and your subject. Smaller light sources will give you a harsher quality of light. Larger light sources produce a softer quality of light.

The best way to illustrate how the size of your light source affects the quality of the light is to go into the studio and show what happens as you increase the size of your lights.

You may have considered the fact that the sun is a huge light source but it produces nasty, ugly shadows for most of the day. This is where another rule of light comes into play: a light source that is far away from your subject will produce a harsh quality of light. Even though the sun is massive in size, it is also extremely far away. The distance from the sun to the earth turns the huge light into a pinpoint source, resulting in the characteristically harsh and deep shadows that define an image taken outdoors

for much of the day. Light sources that are closer to your subject produce a softer quality of light.

The results of assignment 32 (facing page) are actually due to two factors: the size of the tracing paper is larger than the bare flashlight, but it is also closer to the object. If you want to see the impact of the larger light source by itself, then place the paper where the flashlight was (2 feet away) and move the flashlight back the same distance between the light and the paper. The shadows will be darker than they were after the original assignment but lighter than with just the flashlight. Pages 108 and 109 show real-life examples outside of the studio.

LEFT—Scenics and certain landscapes can be a better choice than portraiture in less-than-ideal lighting situations. Rizal Park in Manila is still beautiful, even on a cloudy day. The light is soft and diffused, but notice the lack of directionality and shadows in the photograph.
RIGHT—Window light is a great starting point when it comes to examining light and learning how it works. The light is soft but still has some direction to it. Model: Tasha Woodfall. Original image in color; black & white adjustment layer added in postproduction.

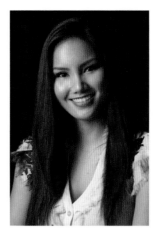

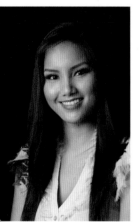

The small spotlight creates what is known as a harsh quality of light. The shadows on Joy's face are deep and dark. The shadows on her face get softer and less pronounced as the size of the light increases. Note that the first image in this series used the parabolic reflector discussed on page 96. The grid narrowed the beam of light to make it a smaller light source.

ASSIGNMENT 32

Set up an area on a table with a piece of white paper as a backdrop. Place another piece of white paper on the table and put an object on the paper. Turn a flashlight on and all other lights off (do this at night or in a room with no windows). Place the flashlight about 2 feet away from the object and note the density of the shadows. Get a piece of tracing paper or other white translucent material and place it between the flashlight and the object. The tracing paper is now the light source for your object, even though you are using the flashlight to illuminate it. You will see softer shadows with the paper as the light source.

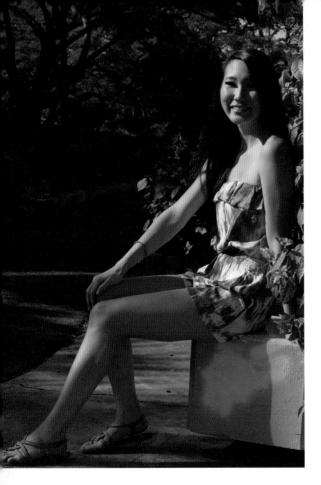
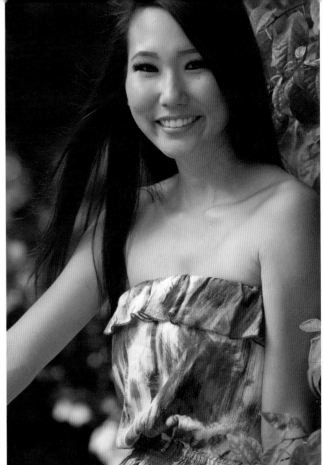

LEFT—The sun is actually a very harsh light source for most of the day. This photograph of Kirstie was taken at about 4:00PM, and the image shows the characteristics of a harsh quality of light—deep, dark shadows that appear quickly when compared to the highlight areas.

RIGHT—This image of Kirstie was created with a scrim and has a much softer quality of light that is due to two factors: The scrim is now the main light and is larger and much closer to her than the pinpoint light rays reaching her from the sun. The exposure under the scrim is different than it was in direct sunlight. Notice how the background is lighter as a result. This technique works best with a darker background.

FACING PAGE—We combined the lessons from the last two sections by adding a silver reflector to the set. The reflector bounces direct sunlight back into Kirstie's hair to add highlights and contrast that create a very pleasing portrait. Thanks to Robert and Joan for assisting on this shoot.

ASSIGNMENT 33

Set up an area on a table with a piece of white paper as a backdrop. Place another piece of white paper on the table and put an object on the paper. Turn the flashlight on and all other lights off (do this at night or in a room with no windows). Bring the flashlight very close to the object and place it at a 45 degree angle to it. Notice how the shadows look. Now slowly pull the flashlight back and watch as the shadows get darker.

ASSIGNMENT 34

Do you want to see how this works in the field? You do not need a commercial scrim to create soft light. A trip to any major home improvement store for PVC tubes and a fabric store for thin white material will do the trick! Make a homemade scrim and start to create pleasing portraits all day long. Remember to meter the light under the scrim.

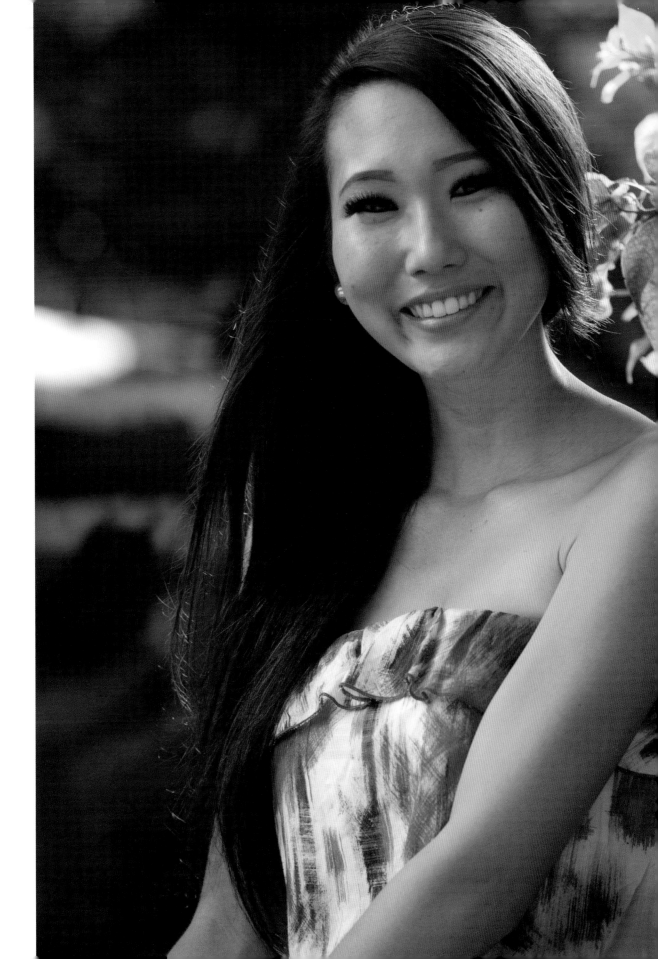

9. COMPOSITION GUIDELINES

Guidelines, not Rules

You now have a good understanding of how your camera works and how to use light to capture the best-possible images. Now let's build on those lessons by going over some composition guidelines. I used to call them "rules," but that is too rigid of a term. Guidelines are flexible, and there will be many times when you will bend them by incorporating other strategies to keep your viewer involved in the photograph. That, in a nutshell, is the main job of a photographer. All of the technical skills can only help so much if the images are not interesting. These guidelines are just a starting point for you.

A good composition is the key to keeping your viewers engaged with your photography. Joan took a really good photograph and improved it by cropping out some dead grass and moving the bridge slightly off center. I love how the bridge directs your eyes off into the unknown.

I am guilty of placing my main subject right in the middle of the image sometimes. The top image is Opaekaa Falls in Kaua'i, Hawaii. It is a pretty photograph of a pretty location—but it is boring. The image on the bottom of the page is of a really cool rock in Boracay, Philippines. The rock is an unusual shape, and the statue keeps your interest momentarily, but the reality is that there is not much in either image to hold your interest and attention.

Guideline 1. *Move the main point of interest out of the center of the image.* One of the critical components of your composition is the position of your main point of interest. The most common placement of the point of interest is right smack in the middle of the photograph. I am sorry to say it, but that is also the least interesting place to put it. A series of photographs with the main subject in the middle each time gets boring fast!

You don't give your main subject any support when you place it in the center of the image. The camera angle is always the same, and the rest of the frame goes to waste because you cannot do anything to accentuate the image. There are four "power points" within your frame, and simply moving

LEFT—Draw an imaginary tic-tac-toe board over your image frame. The frame is now broken up into one-third segments that run vertically and horizontally. The spots where the lines intersect are the power points.

RIGHT—The Golden Mean is the second main way to find your power points. Divide your frame as indicated in the diagram above to use this method. Note that the power points are in the same place. Simply "flip" the diagram to find the other two power points. It is just a matter of which one you "see" better.

ABOVE—Positioning yourself or your friends in the center of the image can work for a portrait, but it won't necessarily make an interesting vacation photo. I cropped a much better photo to illustrate this point. We'll see the original, better-composed photo soon.

LEFT—Here is the same rock in Boracay that we saw before. The rock is now a good deal to the right of the frame and slightly above midline. It is still the center of attention, but now I am able to use a different camera angle. I am free to use other strategies such as incorporating the lines of the clouds and the foreground shadows to lead the viewer's eye to the rock.

the main subject to one of these points will almost automatically create a stronger image. You also have the opportunity to use the rest of the frame to lead the viewer's gaze to your subject and keep him or her engaged in the photograph.

How do you find these "power points?" There are two common methods that lead you to the same places. One is called the "Rule of Thirds." The other is called the "Golden Mean."

TOP—This could easily be a boring image, but positioning the catamaran in the lower-right corner gives it room to breathe. The sharp diagonals that converge on the front of the boat lead your eye farther into the photograph where one of the many islands of Fiji awaits. The thick white clouds create a point of contrast for the dark-blue sky.

BOTTOM—Fortunately, our tour guide knew to move Joan and me off center so the unique Chocolate Hills of Bohol, Philippines, could become an integral part of this image.

I also like heavy bases or bottoms in my images. I then use the rest of the frame to balance the feel of the image. The clouds break up the sky in this photograph of Waikiki, Hawaii, and keep it from becoming too dominant of an element.

Guideline 2. *Use lines to draw the viewer into the photograph.* Another guideline that you can employ to improve your composition is to use lines to draw your viewer into the photograph and to the point of interest. Look through your viewfinder to find strong entry points as well as exit points. Use lines at the entry points to bring your viewer in and find ways to redirect them from the exit points.

TOP LEFT—Here the sailboat off of Boracay is the main point of interest, and it is almost in the center of the frame. Wait! Didn't we just say *not* to place the main subject in the middle of the image? I used strong lines to counteract the placement of the boat and created a frame within the frame to lead viewers to the blue sails. The wires in the upper left are subtle yet important because they block a natural exit point in the photograph.

BOTTOM LEFT—I used the lines on the left of the image coupled with a low camera angle to draw your eye to what I think is an awesome lifeguard stand. I left plenty of room on the right to set the scene as a beautiful tropical paradise. Boracay, Philippines.

FACING PAGE—Repeated lines can be used as powerful compositional tools. However, you also want to be aware of where the lines will lead your viewer out of the photograph. Find ways to block the exit points. The wooden frame was included on purpose to block the viewer from following the lines of the sails out of the frame.

ASSIGNMENT 35

Pick up a magazine that you like and look at the photography. Which images hold your attention and interest? Which ones do you pass over quickly? Why? What are the differences?

ASSIGNMENT 36

Break away from the center of your frame! Go out and create ten photographs in which you consciously move the main subject into one of the four "power points."

ASSIGNMENT 37

Look for your entry points and exit points within your frame. Create ten images with strong lines to draw your viewer in, and then find ways to block the exit points.

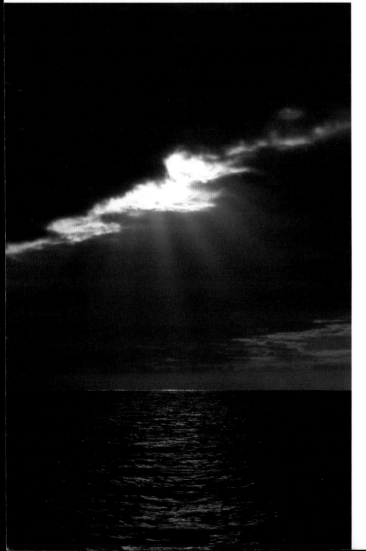

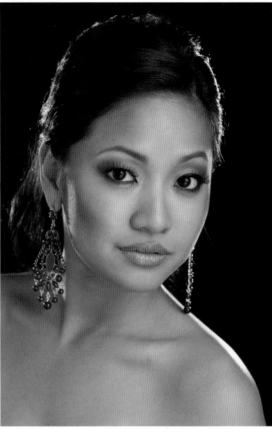

TOP LEFT—I almost blew this shot! We were on a small wooden boat in the Philippine Sea at the end of a cruise, and I think the driver wanted to get home. What a bumpy ride! I barely got the left-hand portion of the cave in the frame. The image really does need more of the rock on that side, but I was happy that the camera did not go overboard. The dark rocks and platform form the base of the scene, while the lighter mountains and sky provide the needed contrast. The flags add a splash of color.

BOTTOM LEFT—This is a color photograph that seems monochromatic. The only point of interest in the photograph is the contrast from dark to light. The diagonal break in the clouds is much more interesting than a straight horizontal line.

ABOVE—The color of Serena's earrings provides the point of highest contrast in this image and highlights what is arguably the main point of interest in what could be a commercial advertisement for the jewelry. The image was carefully cropped so Serena's dress would not compete with the jewelry.

Guideline 3. *Use color and contrast to draw the viewer's eyes into the photograph.* Your viewer's eyes will go to the point of highest contrast in your image. The contrast could be light and shadow or color. Use this bit of human nature to your benefit when composing your photographs. (See the images on the facing page for examples of how this works.)

Guideline 4. *Never crop into your subject's head.* The first word of this one is enough to tell you that I wasn't serious. Avoid any composition rules that say "always" or "never!" Well, okay—this is actually a good rule of thumb in *most* situations.

ASSIGNMENT 38

Spend time studying the color and contrast of your scene and create ten images that emphasize these components.

ABOVE—You *do* typically want to include all of your subject's head in the frame, as in this portrait of Sharon Sanchez.
RIGHT—There are times when I break this guideline on purpose. I like the visual tension it provides. The nontraditional cropping of this fashion image of Ashlee Kozuma puts the emphasis on her necklace.

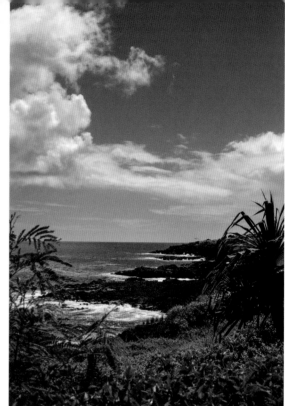

ABOVE—Joan chose a large f-stop (small number) and moved in close to use selective focus to isolate and draw your attention to this beautiful plant.
TOP AND BOTTOM RIGHT—Spouting Horn is a famous blowhole on the South Shore of Kaua'i. Waves of water get pushed through lava tubes and come out in a cool water spray at the surface. Joan created a great image of the blowhole, but no one looked to the right to see or photograph the beautiful coastline.

Guideline 5. *Use selective focus to draw attention to the subject.* You spent a lot of time and effort during this class learning how and when to control your depth of field. "Selective focus" is a term used to describe when you use a shallow depth of field to emphasize your main point of interest and de-emphasize other components of the scene.

Guideline 6. *Look around.* One of the most important things that you can do to improve your travel photography is to look around! There are so many times that I go to a famous location and see carloads of photographers show up, grab "the shot," and get back in the car to move on to the next spot. More often than not, the best image is not what they came to photograph, and they miss it because they just did not look around. I saw this on at least two occasions on this trip.

Guideline 7. *Use the frame to tell a story.* We have all heard the saying "A picture is worth a thousand words." This really captures the essence of what we want to do when we push the shutter release and create an image. Use the guidelines above and others to fill your frame with information that tells a story!

ASSIGNMENT 39

Shoot ten images using crops that might initially be out of your comfort zone. Note that there is a way to practice this until you find a style that you like: shoot wide and crop tight in Photoshop, but eventually start taking the risk of creating cropped images in camera.

ASSIGNMENT 40

Take all that you have learned so far and create ten different images in which you emphasize the main subject by using selective focus techniques.

TOP—I ask my students if this image is a portrait. The answers I get are almost always split 50-50. Some say that it is not a portrait because you cannot see his face. I then ask if the image tells you about this gentleman. Is he content with his job? Is he good at what he does? Is he comfortable with his surroundings? A portrait is an image that tells a story about a person, whether in a "formal" fashion or a more "environmental" motif. I used many of the guidelines listed in the previous pages to create this image. Can you identify them?

BOTTOM—This very simple composition creates an image with a lot of tension. The sail of the boat tells us that they are not sailing into a dark abyss. Are they going to make it? I underexposed this photo to increase the drama.

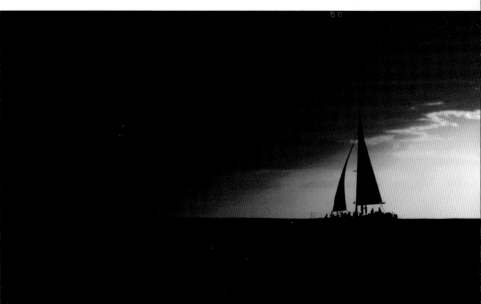

10. USING FLASH

A detailed discussion of how to use your flash is beyond the scope of this book, but I wanted to end this class with a few points that will help you to create better photographs with strobes. You can download a very detailed supplement that covers flash photography at www.hawaiischoolofphotography.com. The supplement is free when you register and provide proof of purchase for this book.

A flash, also known as a "strobe," will add light to any scene. When would you use a flash? The most common use for a flash is in a dark environment, like indoors when you don't want to shoot at a high ISO. In these cases, the light from the flash is often the only light that your sensor registers. Your exposure is primarily based on the amount of light coming from the flash. There might be times, like in the image of Joan below, when you choose to use a flash in brighter areas, like outdoors during the day. In these cases, the light from the flash will combine with the ambient (existing) light for the exposure. It is important to note that the amount of light coming from your flash will be the same whether you use it indoors or outdoors. The existing light has no effect on what comes out of your flash.

Ideally, the flash will emit the same amount of light every time it fires or "pops." You are used to measuring light as a combination of shutter speed and f-stop at a certain ISO. The situation is a little different with a flash. The intensity of the light coming from the flash is measured in terms of f-stops because the strobe does not care about the shutter speed: it will supply the same amount of light with a shutter speed of $1/15$ second or $1/200$ second.

How much light the flash gives you depends on how powerful it is and/or the power setting you choose. A weak flash, or one on a low power setting, might give you a reading of f/4. This means that you would need to set your camera to f/4 (a large opening) because of the

Joan jumps over Honolulu, Hawaii! The shutter speed was fast enough to freeze her action and slightly darken the background. The image was created using a powerful studio strobe outdoors. The flash added light to the existing outdoor light. You will need a light meter that can read the ambient (existing) light, the light from the flash, and the combination of these two light sources.

small amount of light coming from the strobe, assuming that the flash is the only light used to illuminate the scene. A powerful strobe set to full power can require an f-stop of f/22 or smaller (larger number).

Consistency/quantity. Most of the DSLR cameras come with a built-in, pop-up flash, and it can be very tempting to rely on them for additional light in darker situations. However, they have some major drawbacks, including, most importantly, a severe lack of consistency in the output from pop to pop.

"Speedlights" (small on or off-camera flashes) or studio strobes are really the only way to go when using a flash for anything more serious than a snapshot. These lights are designed to be consistent every time they fire. You simply need to know how much light you are getting each and every time.

How can you tell how powerful your flash is? The best way to determine this is to thoroughly test the unit across a variety of situations, but a starting point is something called the "guide number."

Controlling Your Background Exposure and the Depths of the Shadows. There is an old saying that your shutter speed will control the density of your background while your strobe will determine your f-stop. This is an accurate but fairly simplistic description of what happens. To reiterate, the f-stop from your flash will not change as you change your shutter speed. However, we know that the f-stop of the ambient light will change if you change your shutter speed and maintain a consistent exposure. The light from the strobe will not affect your background exposure unless your subject and the backdrop are very close. A fast shutter speed will do two things for your image:

Kristen was photographed in a darkened studio with a midrange shutter speed ($^1/_{125}$ second) and a low ISO. The only measurable light came from the strobes. The strobes were metered using an incident light meter that read the light from the flash. The shutter speed and ISO were "dialed in" to the meter. The f-stop obtained by the strobes was set on the camera and the image was created.

ASSIGNMENT 41

Today's modern speedlights can "talk" to your DSLR and produce some pretty amazing results. Unfortunately, that is one more time that we are reverting to "auto" mode rather than understanding what is happening. You will need a light meter that can read flash for this assignment, but it is worth it. I recommend using an incident light meter. Go into a relatively dark room and set your flash up 10 feet away from the meter. Set the meter to ISO 100 (this is how flash manufacturers obtain the guide number for their units). Set the flash to manual mode and fire it at each major change in zoom distance and power setting. Write down each of the results. This will become your master guide for the flash's output.

ASSIGNMENT 42

Take your flash and meter into an outdoor setting with both a bright backdrop and a dark backdrop. Meter and photograph each setting (flash plus ambient) at different shutter speeds and compare the results.

TERMS

▶ Sync Speed

Your camera has a shutter speed that is designated as the flash sync speed. This is the fastest shutter speed that can be used and still record all of the light from the flash. The sync speed has traditionally been in the $^1/_{60}$ to $^1/_{250}$ second range, but today's technology is rapidly expanding that speed. Some "high-speed sync" flash triggers are claiming to sync the shutter at up to $^1/_{4000}$ second and maybe beyond.

Naomye Leiza was photographed on Mount Tantalus overlooking Honolulu, Hawaii. The backdrop for this image was light, so we used a faster shutter speed to darken the sky and water a bit. The shutter speed and ISO were dialed into the hand-held incident light meter, and the f-stop was measured by reading the output from the strobe plus the ambient light falling on Naomye. The exposure was ISO 100 at f/10 and $^1/_{125}$ second.

NEAR RIGHT—We simply turned and faced a different direction to position more trees and the airport behind Naomye. Here the faster shutter speed is not as effective because the backdrop is much darker. You lose too much detail in the trees because the faster shutter speed darkens an area where the tonal values are already low. The impact of the flash on Naomye is very apparent; it is obviously the main light. The exposure was ISO 100, f/8, and $^1/_{100}$ second.

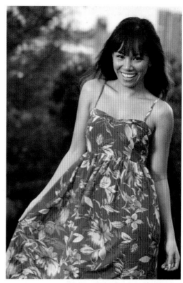

FAR RIGHT ABOVE AND RIGHT—We "dragged the shutter" slightly and opened the aperture a little for these two images. The additional ambient light recorded completely changed the look of the scene. There is detail in the bushes behind Naomye and the effect of the flash is not as apparent on her face. My goal when I use a strobe outdoors is to mimic the natural look and feel of the scene. I don't want my image to look like I used a strobe. The exposures were ISO 100, f/6.3, $^1/_{50}$ second and ISO 100, f/7.1, $^1/_{30}$ second respectively.

the background will be relatively darker and your flash will act more like a main light. Be careful not to set your shutter speed faster than your camera's flash-sync speed.

"Dragging the shutter" is a phrase used when you shoot with flash and a slower shutter speed. The slower shutter speed allows more detail to show in the background and provides a more even relationship between the light from the flash and the ambient illumination.

Using Light Modifiers with Flash. The size of your flash and/or light modifier will affect your quality of light. We examined this concept earlier when we used a scrim to modify and soften direct sunlight. The same rules apply when using flash: small flashes yield a harsher

quality of light. Some flashes, like most built-in, pop-up flashes are very small, but the reality is that all flashes, including the flash tubes on larger studio strobes are small, harsh light sources. The big difference lies in the power of your unit. Powerful flash units allow for more options and more ways to modify the light falling on your subject. Less powerful strobe units give you fewer options because you will lose light as you modify it. Light modifiers are any things that move or spread light, and they come in many different types and sizes. Many wedding photographers will bounce a flash off of a wall or ceiling to produce a softer effect. Other times you can shoot your flash through fabric or attach modifiers called softboxes to

The first image was created with a speedlight shot through an 8-inch scrim. The scrim enlarges the light from the small flash, but it is still a relatively small light source that produces sharply defined shadows and distinct highlight patterns. A second speedlight was hidden behind the tree and was fired directly at Erin's hair to provide a separation light. The image on the right was created with an 18-inch beauty dish with a white diffusion "sock" attached. The strobe for the second image was a Dynalite Uni400 monohead. The type of strobe used doesn't matter per se, except for the increased power of the Uni400. The increased power allowed me to attach a larger light modifier and still get the f-stop I wanted. I actually used neutral density filters to bring the f-stop down to f/4.5 to limit the depth of field.

the strobe.[5] It is important to remember that while the flash or strobe is providing the initial blast of light, your light modifier determines the final size of your light source.

Positioning Your Flash. The direction of light has some distinct implications when using flash. Your decision about where to place the flash will determine the direction of the light and how the shadows fall from your subject, especially if the flash is set up as your main light. On-camera flash sends light directly at your subject and creates an even spread of light across your entire scene. Shadows are often nonexistent, and the result is a less-than-appealing flat image in most cases. However, on-camera flash can be very effective when you use it as a fill source to soften the shadows created by another light source.

There are many more facets to successfully integrating a flash into your photography. You've come this far, so go get your supplement at the website listed above.

I sincerely hope that this course has moved you from a "picture maker" to an "image creator."

▶ **The direction of light has some distinct implications when using flash.**

5. See my book *Softbox Lighting Techniques for Professional Photographers* (Amherst Media, 2007).

ASSIGNMENT 43

Find, make, or buy scrims or other light modifiers to place in front of your flash to soften the shadows created by the small light source.

ASSIGNMENT 44

Move your flash off-camera and start controlling where your shadows fall. Place the strobe in a stationary position relative to your subject and you won't have to deal with changing exposures as you move the camera closer or farther away.

ASSIGNMENT 45

Please like our school on Facebook (www.facebook.com/hawaiischoolofphotography) and leave a note or share some of your images! Visit www.hawaiischoolofphotography.com for more educational opportunities. *Mahalo!*

ABOVE—Pop-up or on-camera flash can be great when capturing special moments in a pinch. Joan and I got engaged earlier in the evening and needed light to capture our first dinner as fiancé/fiancée. The pop-up flash did the trick, but notice how harsh and flat the light on our faces is. It is a great moment, but hardly a great portrait.

RIGHT—The strobe was moved off-camera and created a more pleasing three-dimensional feel to the image. It was getting dark, so I dragged the shutter down to $1/13$ second to show some detail in the trees behind Joan. My other books from Amherst Media discuss lighting in depth. Big thanks to Marshall and James for helping with this shoot.

INDEX

A

Adobe Lightroom, 82
Adobe Photoshop, 32, 82
Angle of incidence, 99–101
Aperture, 13, 14, 27, 32–36, 37, 38, 39, 40, 41–43, 44, 45, 48, 49, 50, 51, 55, 65, 72, 73, 123

B

Background, 47
Beauty dish, 17, 91
Bouncing light. *See* Reflectors.

C

Camera shake, 53, 54, 55
Capture media, 9, 10, 17–19, 20, 27, 29, 30, 32, 41, 43, 44, 46, 55, 73, 83, 84, 120
 digital sensor, 9, 10, 19, 20, 27, 29, 30, 32, 41, 43, 44, 46, 55, 73, 83, 84, 120
 film, 18–19
Color, 24–25, 60, 61, 74–82
 balance, 80–81

(Color, *cont'd*)
 channels, 24–25
 checkers, 82
 space, 74–75
 temperature, 75
Composition, 112, 113

D

Depth of field, 46, 47, 48, 49, 50, 86
Detail, 61
Distortion, 86, 91, 92

E

EXIF data, 36, 40
Exposure, 27–45, 53, 56, 62, 63, 64, 65, 68, 73, 98, 119

F

Field of view, 83
File formats, 21–23
File numbering, 22
Filter, neutral density, 124
Flash. 17, 71, 73, 75, 91, 96, 120–25. *See also* Speedlights
Flashlight, 99, 103, 106

Focal length, 41, 55, 82–94, 95
Focal plane, 46, 47, 48
Foreground, 47
F-stops, 34, 41–43. *See also* Aperture.

G

Golden mean, 112, 113
Grain, 30
Grids, 107
Guide numbers, 121, 122

H

Highlights, 12, 26, 27, 39, 59, 60, 61, 65, 67, 68, 71, 73, 88, 95, 98, 99, 101, 105, 108, 116, 124
High key, 73
Hue, 61
Hyperfocal distance, 46

I

Image sensors, 9, 10, 19, 20, 27, 29, 30, 32, 41, 43, 44, 46, 55, 73, 83, 84, 120
Info/display button, 11

OTHER BOOKS FROM
Amherst Media®

Lighting and Design for Portrait Photography

Neil van Niekerk shares techniques for maximizing lighting, composition, and overall image designing in-studio and on location. *$27.95 list, 7.5x10, 128p, 200 color images, order no. 2038.*

The Big Book of Glamour

Richard Young provides 200 tips designed to improve your relationship with models, enhance your creativity, overcome obstacles, and help you ace every session. *$27.95 list, 7.5x10, 128p, 200 color images, order no. 2044.*

The Mobile Photographer

Robert Fisher teaches you how to use a mobile phone/tablet plus apps to capture incredible photos, then formulate a simple workflow to maximize results. *$27.95 list, 7.5x10, 128p, 200 color images, order no. 2039.*

The Beckstead Wedding

Industry fave David Beckstead provides stunning images and targeted tips to show you how to create images that move clients and viewers. *$27.95 list, 7.5x10, 128p, 200 color images, order no. 2045.*

Alternative Portraiture

Benny Migs presents sixty edgy portraits, lighting diagrams, alternate shots, and to-the-point techniques to show you how to create stand-out portraits. *$27.95 list, 7.5x10, 128p, 200 color images, order no. 2040.*

Portrait Mastery in Black & White

Tim Kelly's evocative portraits are a hit with clients and photographers alike. Emulate his classic style with the tips in this book. *$27.95 list, 7.5x10, 128p, 200 images, order no. 2046.*

The Speedlight Studio

Can you use small flash to shoot all of your portraits and come away with inventive and nuanced shots? As Michael Mowbray proves, the answer is a resounding yes! *$27.95 list, 7.5x10, 128p, 200 color images, order no. 2041.*

Power Composition for Photography

Tom Gallovich teaches you to arrange and control colors, lines, shapes, and more to enhance your photography. *$27.95 list, 7.5x10, 128p, 200 color images, order no. 2042.*

Nudes on Location

Overcome common obstacles to capture gorgeous nude and glamour portraits in any outdoor location. Bill Lemon provides an intimate look at what it takes to succeed. *$27.95 list, 7.5x10, 128p, 200 color images, order no. 2043.*